IN OLD PHOTO

BRITA

IPSWICH

PAST & PRESENT

DAVID KINDRED

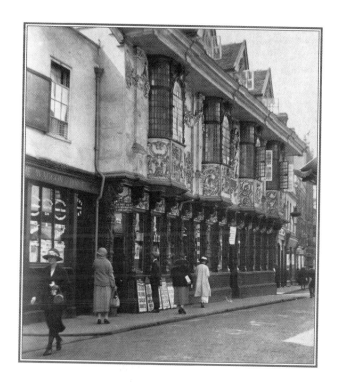

SUTTON PUBLISHING

Sutton Publishing Limited
Phoenix Mill · Thrupp · Stroud
Gloucestershire · GL5 2BU

First published 2004

British Library Cataloguing in Publication Data
A catalogue record for this book is available from the
British Library.

ISBN 0-7509-3921-4

Typeset in 10.5/13.5 Photina.
Typesetting and origination by
Sutton Publishing Limited.
Printed and bound in England by
J.H. Haynes & Co. Ltd, Sparkford.

Title page photograph: Buttermarket, with the Ancient House and the Wagon and Horses public house (left), *c.* 1920. The fifteenth-century Ancient House is a Grade I listed building which has had several uses. For much of its life it was home to the Sparrowe family, and it is believed that King Charles II hid here after his defeat at Worcester in 1651. Panels on the building represent the four continents known of in the seventeenth century. Captain Cook had not then discovered Australia. The Royal Coat of Arms of Charles II appears on the front of the building. The Wagon and Horses was replaced by the Ritz Cinema (later renamed the ABC). Part of the Buttermarket shopping centre is now next to the Ancient House.

Below and opposite: The Town Hall at the turn of the twentieth century and in 2004.

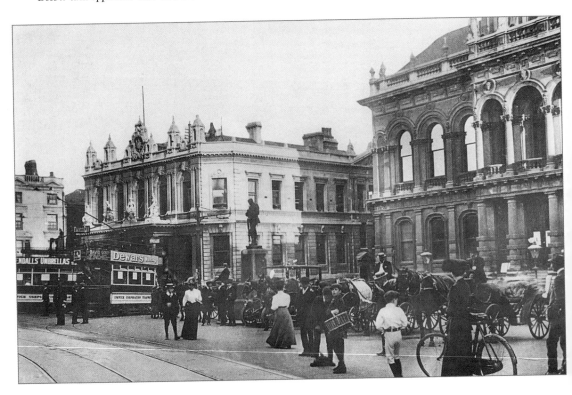

CONTENTS

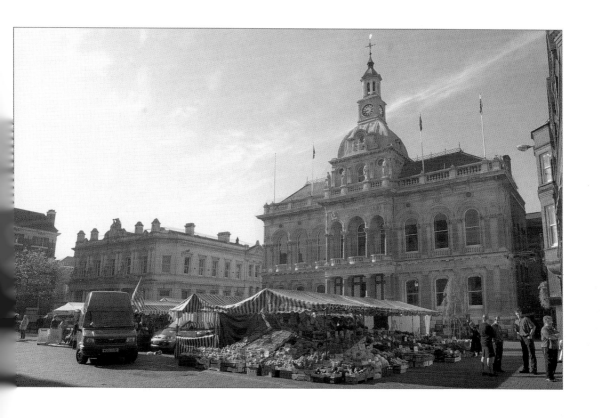

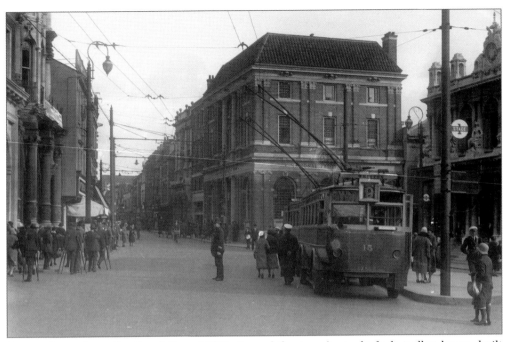

Tavern Street from the Cornhill, *c.* 1930. One of the town's single-deck trolley buses, built locally by Ransomes Sims & Jefferies, is outside the post office.

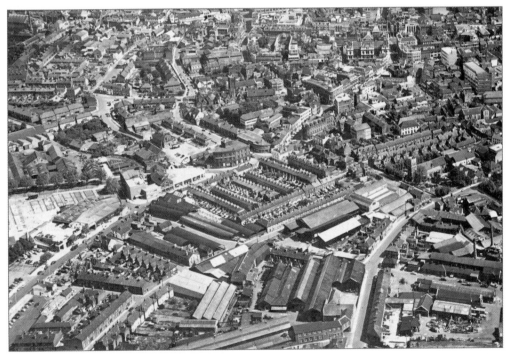

An aerial view of the town centre, mid-1950s. Most of the buildings in the foreground of this photograph taken from above the River Orwell have been replaced. Prince's Street runs from the left of the picture with part of the Cattle Market (centre left). Wolsey Street is in the bottom right-hand corner. Part of the entertainment complex of Cardinal Park is now in the foreground of this view.

INTRODUCTION

There is no way of knowing exactly when Ipswich became a settlement. Gold torcs dating back to the first century BC were found at Belstead Hill in 1968. Nothing was found to tell us anything about the way of life of those who left them there. Iron Age houses once stood where the Whitehouse estate is now, and it is known that Romans occupied the area around Handford Road.

Whatever the details of those early settlers were, as soon as the first structures were replaced no doubt somebody said 'It looked better as it was', just as they do today. The town is forever changing.

The needs of one century do not fit with the next. The Ipswich Dock was a Victorian plan to boost the town's trade where a port had operated for many centuries. January 1842 saw the first ship sail through the lock, then off New Cut, into the 33-acre dock. When it opened it was the largest wet dock in England – bigger than anything in Liverpool or London. The tidal flow of the Orwell had to be redirected, and New Cut was created forming a 14-acre island with a promenade and tree-lined recreation area. This leisure area was lost to industry in the 1920s.

Victorian architecture with some fine brick warehouses were added to the old merchants' houses around the Fore Street area. These are being restored into restaurants and bars, all unimaginable to those who spent their working life there.

The giant engineering works of Ransomes Sims & Jefferies was established in the area round Duke Street from 1849. Close by stood the Ipswich Gas Light Company works. Transport of coal for the production of gas arrived by ship. Import and export of grain and its products from the silos of Cranfield's and Paul's saw huge industrial sites fill the area. Now the dock is being transformed into a residential and leisure area. Where barges and ships once loaded and unloaded we see flats and apartments with quayside cafés, restaurants and bars. There are still some industrial sites around the area, but the Waterfront is rapidly changing.

The road layout in the town centre can be traced back hundreds of years. Medieval maps show the route of Carr Street, Tavern Street, Westgate Street, St Peter's Street, Upper and Lower Brook Street and many more, being main routes through the town. The introduction of the electric tram service in 1903 saw many town centre buildings demolished. St Peter's Street, Queen Street and Upper Orwell Street were changed dramatically to accommodate the new form of transport. No doubt there was much protest at the time.

The volume of traffic through the town brought many changes. In the 1950s and '60s the housing around Prince's Street and The Mount area was demolished so that Civic Drive could take through traffic across town.

Most of the housing of the Potteries area around Rope Walk, where the Suffolk College now stands, was also demolished. The tiny streets around Cox Lane were also cleared. Residents were moved to council housing around the edge of town, and satellite villages like Whitton were swallowed up by the growth of the town. It is always sad to see fields and woodland built on, and whenever these green sites are developed there is protest, but today we all live, work or go to school on what was once a greenfield site.

Many of the changes to the town centre were planned in the 1950s, to be built in the 1960s, in a period after the Second World War when sweeping changes seemed the way forward. The changes to Carr Street from a mixture of buildings that had evolved over many years to the distinctive 1960s concrete and glass have never had many enthusiasts for their design. The same is true of St Matthew's Street. The road was too narrow for the flow of traffic in that part of town, so it was changed to a dual carriageway. The 1960s buildings have been altered and partly demolished in an attempt to solve design problems but even now they retain a bleak look.

The Prince's Street area saw the construction of the ill-fated concrete Greyfriars development, also built in the mid-1960s. Most of the shops around the complex stood empty until the site was partly demolished in the 1980s and taken over for office use.

Walking around the town, revisiting the same spots where photographers had stood sometimes over a century earlier, is an interesting challenge. Many of the positions are impossible to get to now. Standing in the middle of the road with a large plate camera was not a problem a hundred years ago when the odd horse and cart might pass, but not a good idea now when huge lorries are thundering by! I have taken the modern comparison pictures from as close to the original site as is practical. Sometimes the building from which the original photograph was taken has gone or a massive structure now blocks the view. In some of the modern views I have included a wider view to help set the scene. Any photograph is a moment in time, and is history as soon as it is taken. These scenes, photographed in 2004, will change quickly. Shopfronts change as new businesses move in. Something as dramatic as a fire or similar disaster is fortunately rare, but some of the pictures of the past I have featured show how streets change after such a drama.

The work of the amateur photographer is important in recording a town's history. Among their photographs there are few of everyday street scenes. Professionals only take photographs if commissioned, and amateurs tend to snap family events and places visited on holiday. No doubt you could find thousands of photographs in local family albums of everywhere except Ipswich. Few ever thought to record the town for the benefit of future generations.

When photographing the streets the everyday things can at first seem to be spoiling the view – lamp-posts, wheelie bins, parked cars – but this is the clutter we take for granted. It is often these very details which make old photographs so interesting. Horses pulling carts around the streets, gas street lamps and elegant Victorian and Edwardian clothes worn to go shopping were just as normal then as what we see in the photographs of today. People will view our way of life with just as much fascination in years to come.

David Kindred, 2004

1

The Town Centre

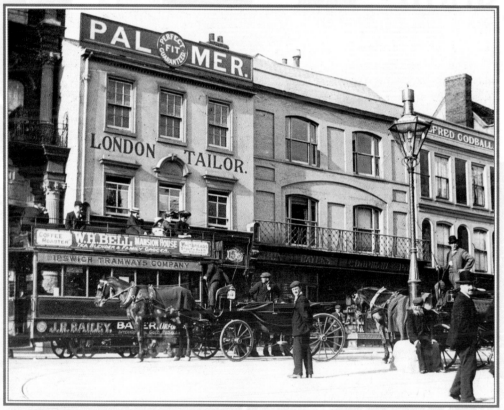

A horse-drawn tram on the Cornhill, 1890s. The tailor's shop on the left is now part of Lloyds TSB Bank. Horse-drawn trams were in service in Ipswich from October 1880 until electric trams replaced them in 1903. This picture from a magic lantern slide was taken from the corner of Prince's Street.

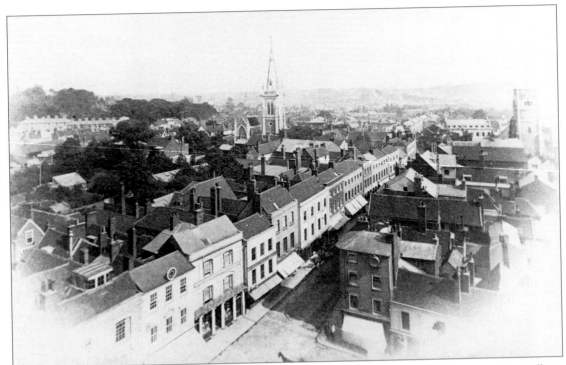

The Victorian town hall on the Cornhill was completed in 1868. In 1890 local photographer William Vick published leather-bound volumes of photographs of the townunder the title *Ipswich Past and Present*. One of the photographs he used was taken from close to the weathervane on the top of the building's clock tower. This view is only possible when builders' scaffolding is in place. Maintenance work lasting many months was completed in early 2004, when I took the opportunity to repeat the view taken 136 years before. The spire of St Mary Le Tower Church is at the top of the pictures. The centre of the view is now dominated by the Tower Ramparts shopping centre.

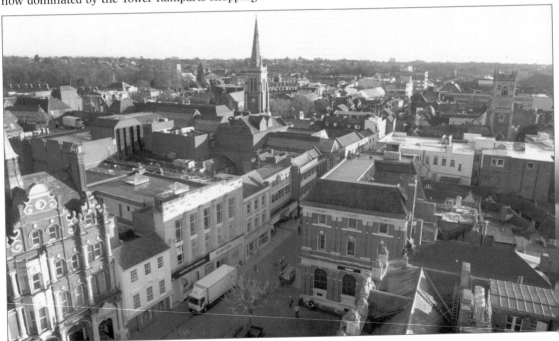

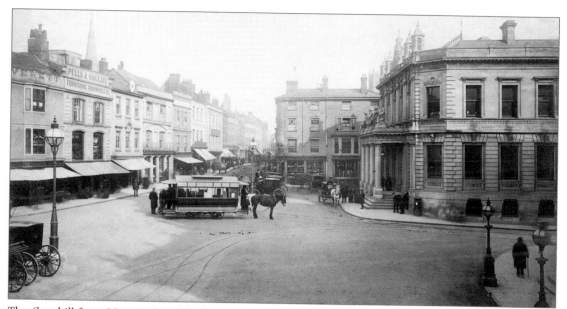

The Cornhill from Manning's public house, *c.* 1890. Buildings on the left were replaced in 1889 by the present red-brick building designed by local architect T.W. Cotman. The Ipswich bank of Bacon, Cobbold, and Tollemache originally occupied it. It is now Lloyds Chambers and Lloyds TSB Bank. The building (third from the left) with the round emblem on the top was F.A. Bales, gunsmith's, premises. The building is now also part of Lloyds TSB Bank, as is the building on the right. It was completed in 1881 as the town's main post office. The statues on the front of the building represent Industry, Electricity, Steam, and Commerce. In the centre is a horse-drawn tram waiting to move off along Prince's Street en route to the railway station.

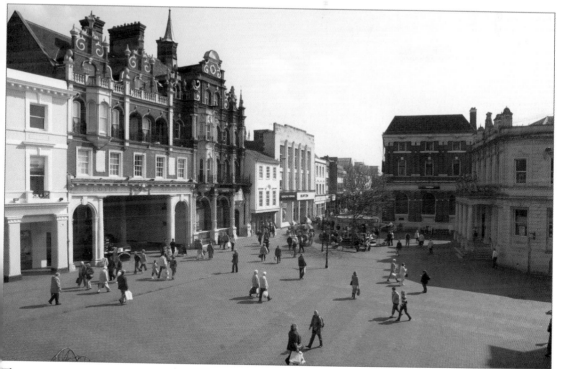

The same view, with the Cornhill an open paved area, April 2004.

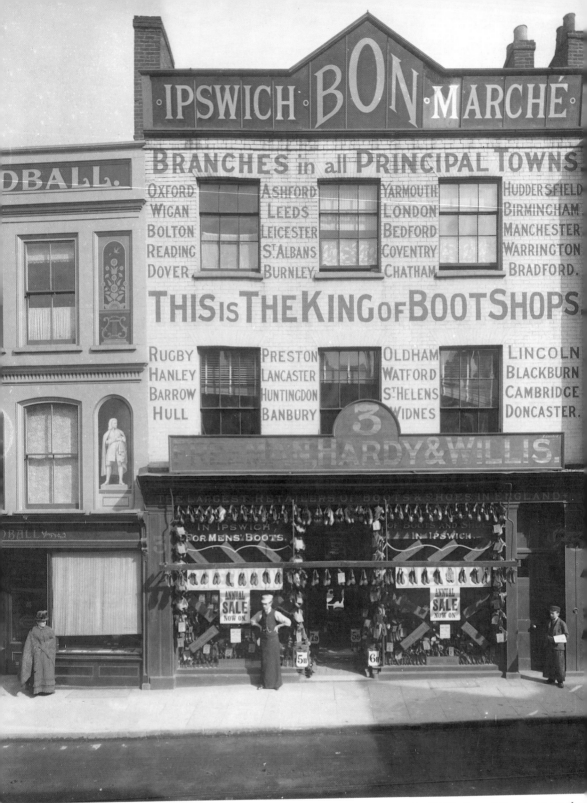

Tavern Street, with Freeman Hardy & Willis's boot and shoe shop at no. 3, 1890. One of the signs on the shop claims that the firm is 'The largest retailers of boots and shoes in England'. The shop on the left was Godball's, retailers of pianos, organs and harmoniums.

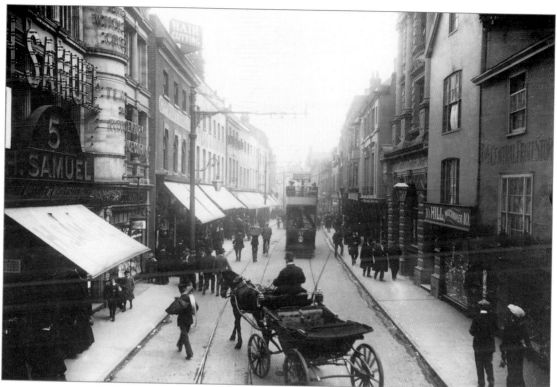

Tavern Street, *c.* 1910. This view was probably taken from the top deck of a tram. The Walk was cut through on the right of this street in 1938. On the extreme left is H. Samuel's jeweller's shop. The entrance to the Tower Ramparts Shopping Centre, which opened in November 1986, is now on the left, where the tram can be seen in this picture.

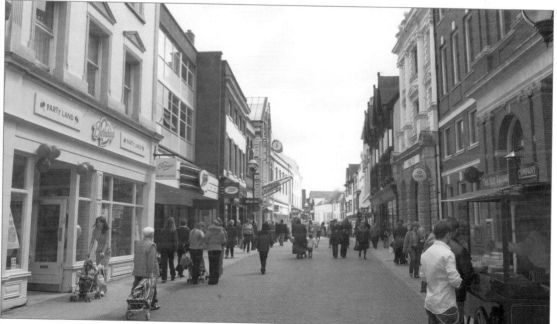

The same view of Tavern Street, May 2004. The street is now paved and closed to through traffic. The building on the left is the one featured on the facing page.

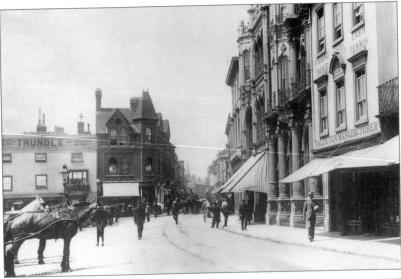

The Cornhill looking towards Westgate Street, c. 1900. The building on the corner of Westgate Street was built on the site of the former Bell Inn after John Henry Grimwade acquired the site in 1879. The clothing store was extended on to the site of the premises next door in 1904.

The Cornhill, 1921. Lloyds Avenue was cut through the building on the right in 1929.

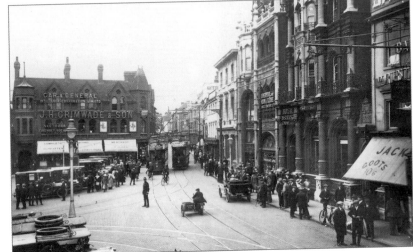

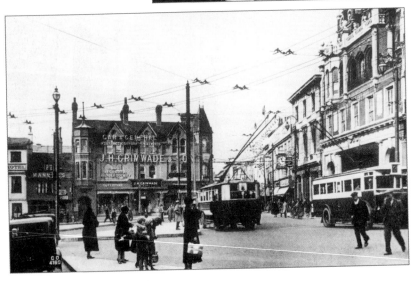

The Cornhill, 1930s. Trolley buses had replaced trams by 1926. Traffic through the town centre was then two-way.

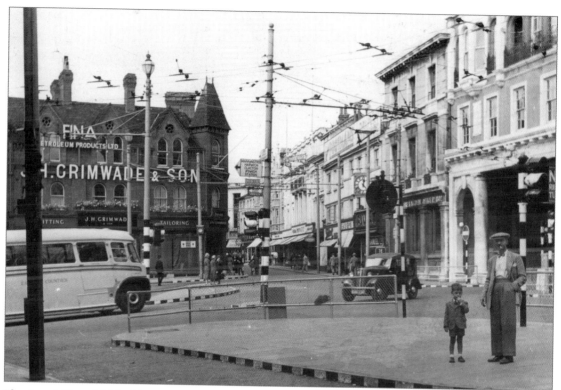

The Cornhill, *c.* 1950. The town centre was cluttered with support poles for trolley buses, and traffic lights controlled the crossroads at Lloyds Avenue, Prince's Street, Tavern Street and Westgate Street.

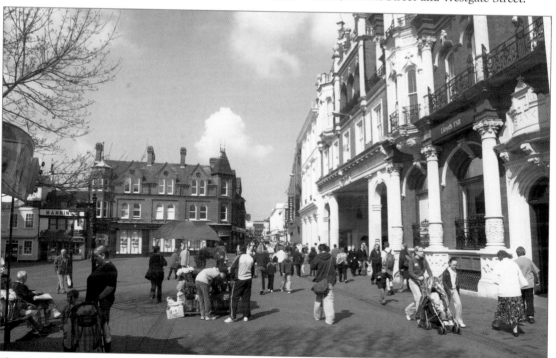

The Cornhill, April 2004. This view is looking into Westgate Street. The clutter of traffic lights and bus shelters has gone with the removal of through traffic.

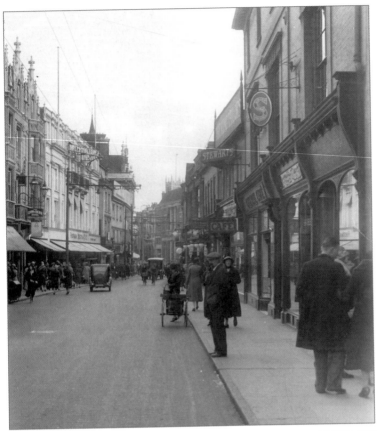

Westgate Street, *c.* 1930. The building housing the Crown & Anchor Hotel, on the extreme left of the picture, is now a W.H. Smith's store. Beyond the hotel is Footman's Waterloo House store, named in 1815 after the Battle of Waterloo, when Robert Footman purchased the business. Buildings on the right when this picture was taken included Stewarts Clothiers, the Oriental Café, and the Singer Sewing Machine Company.

Below: Westgate Street is now part of the town's pedestrian shopping area. Debenham's store has replaced Footman's Waterloo House on the far left.

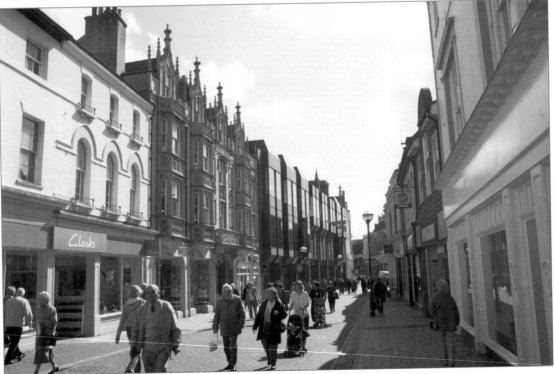

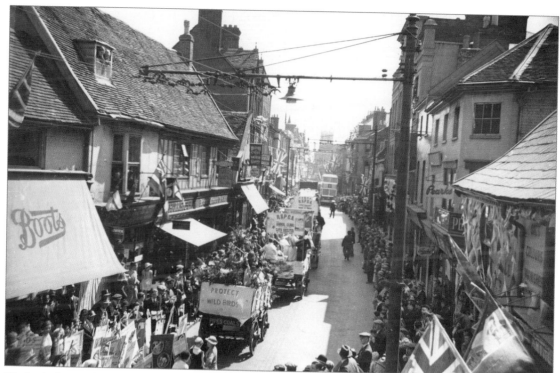

Westgate Street, 6 May 1935. Crowds watch a procession to celebrate the Silver Jubilee of King George V. This view, from a first-floor window near the corner of Lady Lane, has the procession approaching the Cornhill as a trolley bus heads the opposite way. Shops on the left include Boots the Chemists (left) and Halford's cycle shop next to the second float. On the extreme right is Smith and Daniels, the cutlers and tool merchants. At the corner of Black Horse Lane is Pearks' Dairies Ltd.

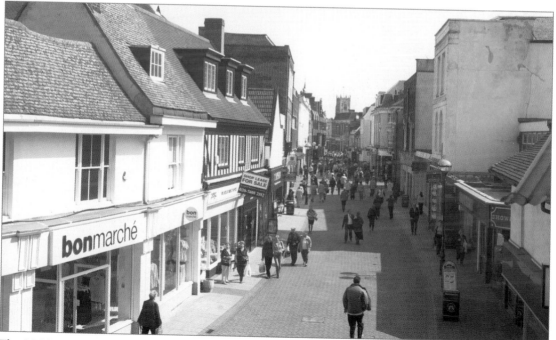

The 2004 view of Westgate Street. In the background is the tower of St Lawrence's Church.

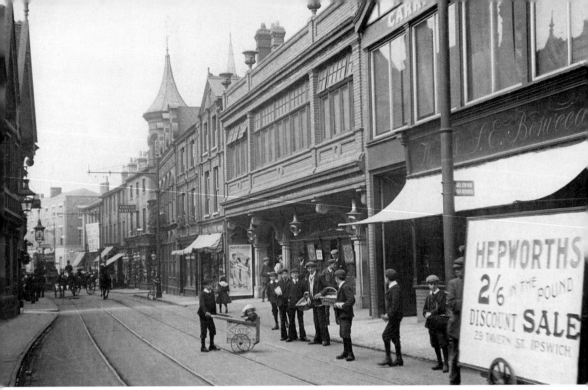

Carr Street, *c.* 1910. This picture postcard view was taken looking towards White Horse Corner. On the right is the Lyceum Theatre, which closed in 1936 to be replaced by the premises of the Great Universal Stores. Further along is the fine red-brick building with a corner turret, which was home to the East Anglian Daily Times Company until they moved to Lower Brook Street in May 1966. The area bounded by Carr Street and Little and Great Colman Street was cleared and the concrete and glass structure that is now the Eastgate Shopping Centre was built.

Carr Street. April 2004. The same view featuring the Eastgate Shopping Centre.

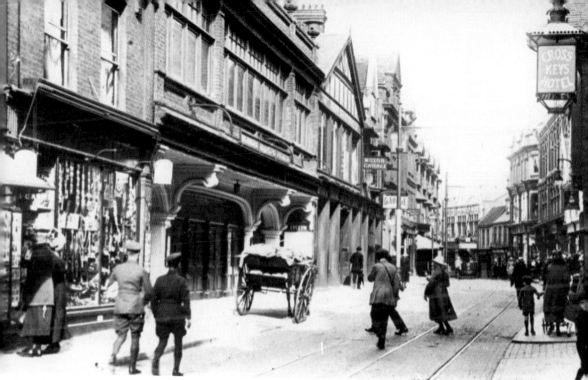

Carr Street looking towards Major's Corner, *c.* 1920. Premises on the left were those of Mrs C. Daniels, costumier, the Lyceum Theatre where Mr E. Bostock was the proprietor and Mrs Edith Parkin the manageress, Botwoods Ltd, motor engineers, and the Ipswich Gas Light Company where Mr Frank Prentice was the engineer and general manager.

The modern view of Carr Street.

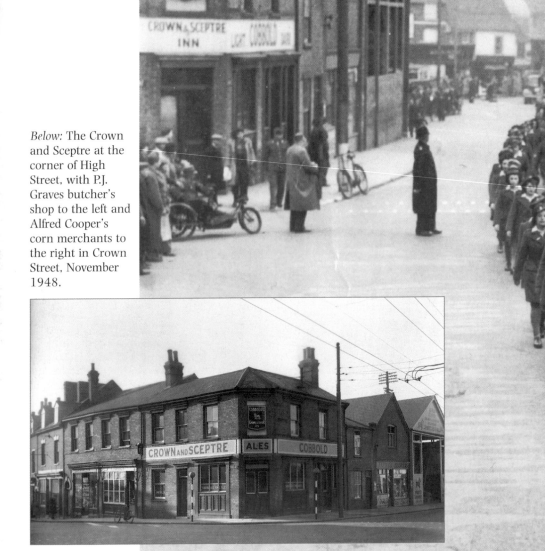

Below: The Crown and Sceptre at the corner of High Street, with P.J. Graves butcher's shop to the left and Alfred Cooper's corn merchants to the right in Crown Street, November 1948.

Left: The same view of the street shows how this busy junction has been widened into a dual carriageway.

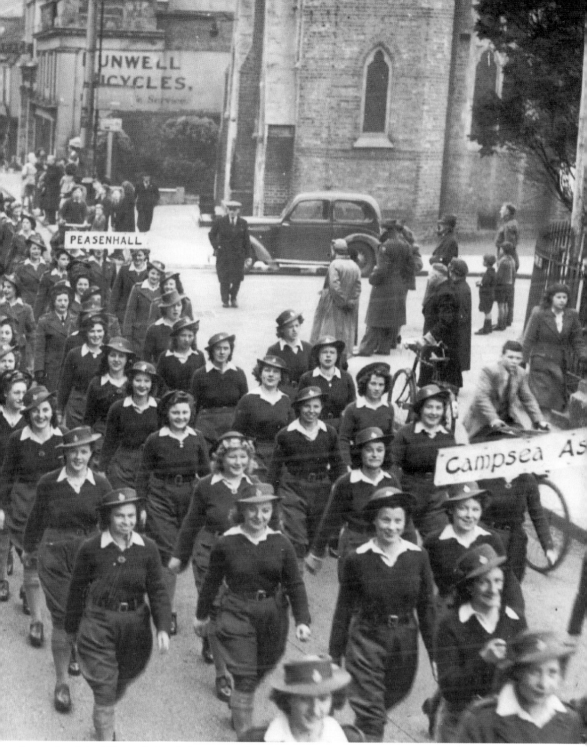

A parade of the Women's Land Army marches across the junction of Crown Street and High Street, 1940s. Every building featured in this view has been replaced. On the left of the picture is the Crown and Sceptre Inn, which was demolished in July 1961, with Alfred Cooper's corn merchants next door. The buildings in the background in St Matthew's Street have also been replaced (see pp. 50–1). On the corner opposite the Crown and Sceptre was the Victorian Crown Street Congregational Church. The iron railing on the extreme right was in front of the Crown Iron Works of George Abbott Ltd.

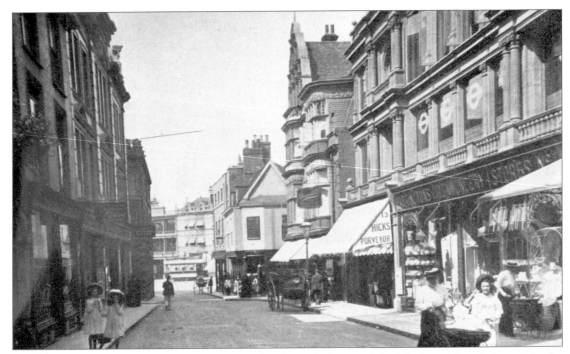

The Buttermarket, *c.* 1915. On the right is Frederick Corder's store. The blind next door belonged to the Hicks Brothers butcher's shop, and beyond that was Burgham's opticians. The building at the corner of the Thoroughfare has been replaced in the modern view.

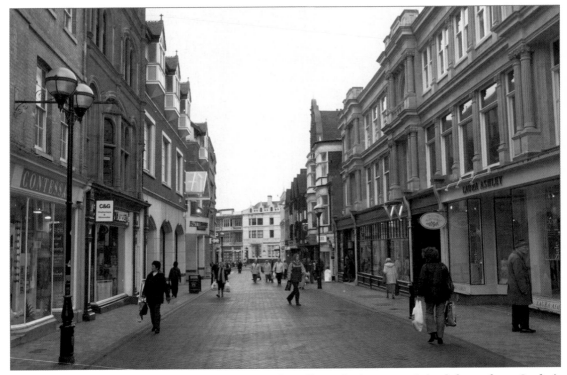

The Buttermarket is now paved and free of through traffic with Waterstone's bookshop where Corder's store was.

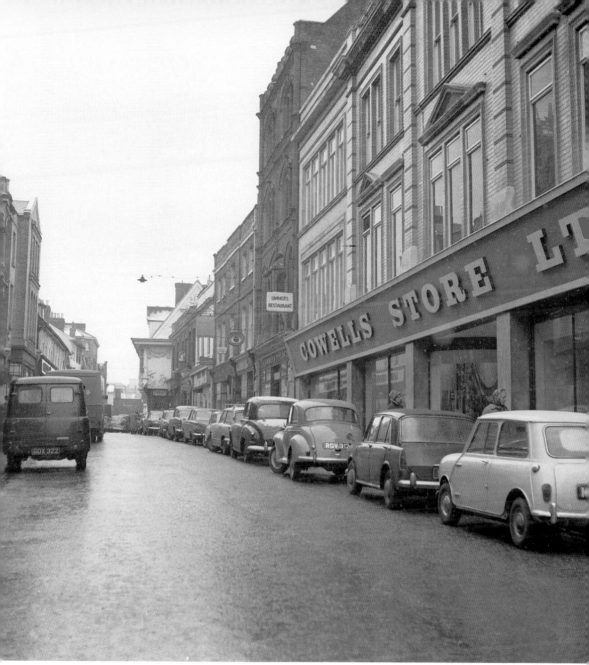

In 1966 parked cars were a feature of the Buttermarket. Cowell's department store on the right has been replaced with the Buttermarket Shopping Centre. Other businesses featured in this view beyond Cowell's were Limmer and Pipe's provisions shop, the District Bank Ltd, A.J. Rawling opticians, James Parnell's shoe shop, Murdoch's domestic appliance shop, and R. Barratt, gold and silversmith. In the background beyond St Stephen's Lane is the Ancient House, then W. Harrison's bookshop.

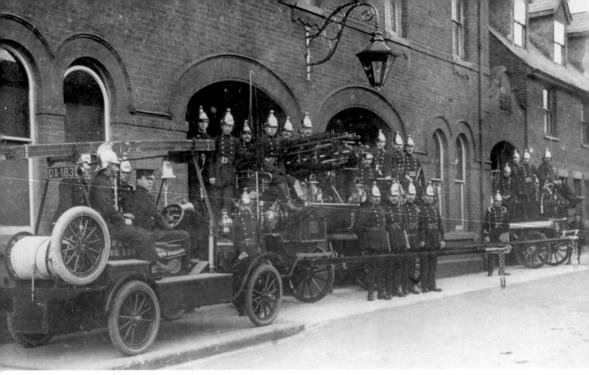

Bond Street, *c.* 1918. The main Ipswich fire station was in Bond Street until new headquarters were built in the mid-1960s. The brigade moved there from nearby premises in November 1899. This picture was taken as the firemen lined up with their new Ford motor tender. Until then the firemen had used horse-drawn equipment, including a steam pump. The horses were last used in 1920. Bond Street served as the town centre fire station until it was replaced by the Prince's Street station.

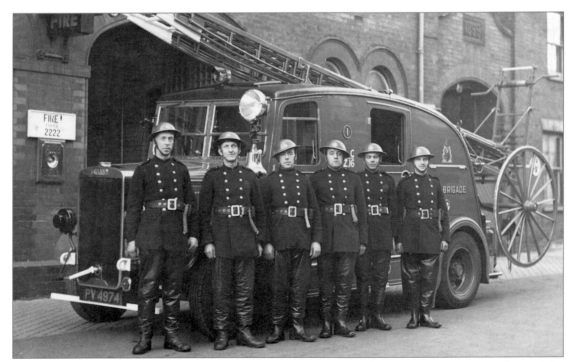

Brass helmets had been replaced by steel when this picture was taken in about 1940. Members of the Auxiliary Fire Service line up with a new Leyland Cub fire appliance. The tender had an Ipswich coat of arms although the word Ipswich was painted out.

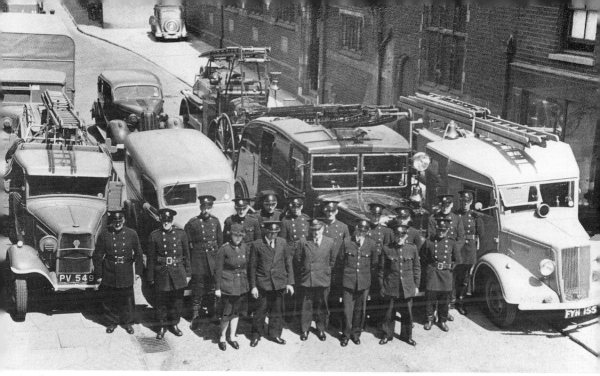

Bond Street, 1940s. Staff of the fire station line up with their equipment during the Second World War. This primitive equipment had to deal with air raids on the town.

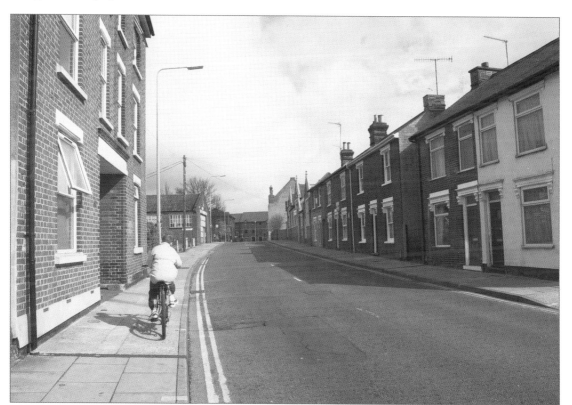

Bond Street, April 2004. The street is now part of the town's one-way traffic system. Little of the former fire station (left) is still standing, although most of the buildings on the right-hand side of the street, including the former Ragged School, are still there.

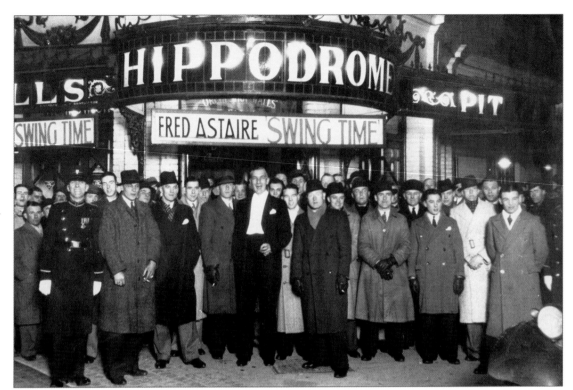

St Nicholas Street, 1930s. The Hippodrome Theatre opened in St Nicholas Street in March 1905, and featured music hall, pantomime and film shows. Its life as a theatre came to an end in 1957. The seats were stripped out and it became the Savoy Ballroom and then a bingo hall. It was finally demolished in 1985. This photograph was taken as members of the Ipswich Town Football Club team arrived to see a show. The commissionaire on the left is George Girling, who worked at the theatre for most of the 1930s.

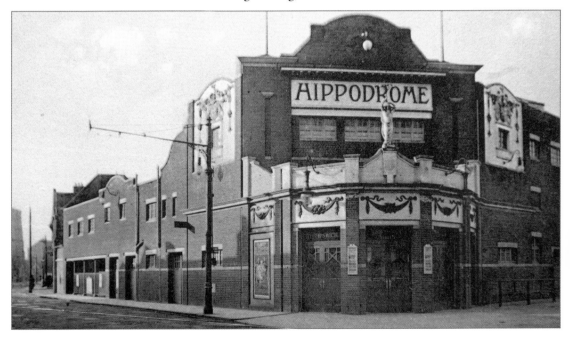

The Hippodrome Theatre as it was in about 1910.

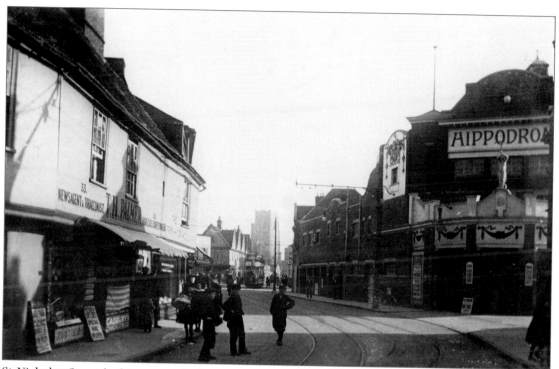

St Nicholas Street looking towards St Peter's Street, *c.* 1915. On the left is T.H. Palmer's newsagent and tobacconist.

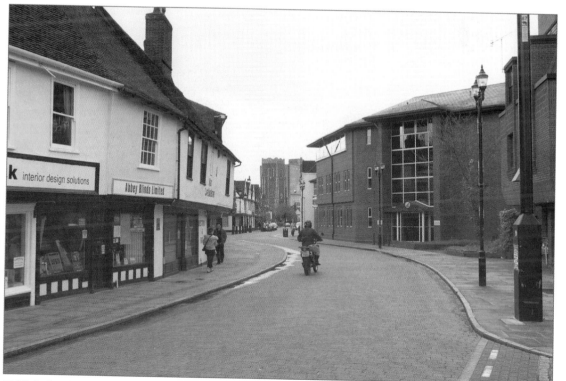

St Nicholas Street, April 2004. An office block has replaced the Hippodrome Theatre.

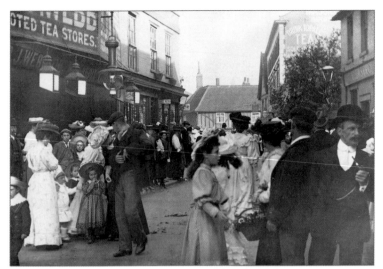

Orwell Place, *c.* 1912. The street was full of elegantly dressed people who were probably waiting for a parade to pass. This splendid picture captures a way of life that has gone forever. In the background is the Spread Eagle public house at the corner of Fore Street and Eagle Street. The buildings on the left have been demolished, but those on the right remain.

Orwell Place from Tacket Street, with the Unicorn Inn in the centre of the picture, 1897. This view was taken during the celebrations for Queen Victoria's Diamond Jubilee. The shops on the left, on the corner of Cox Lane, have gone.

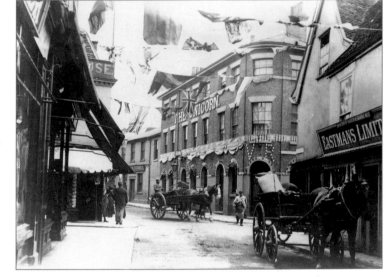

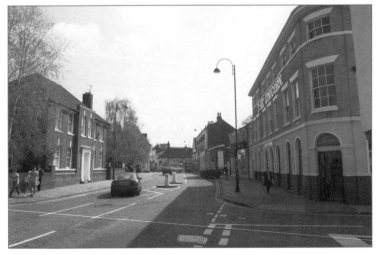

Orwell Place with its modern flow of traffic, 2004.

St Margaret's Plain, *c.* 1920. The road was widened in the early 1930s, at which time the timber-framed building at the junction of Soane Street was altered. The right of the building was rebuilt with new gables facing into St Margaret's Street.

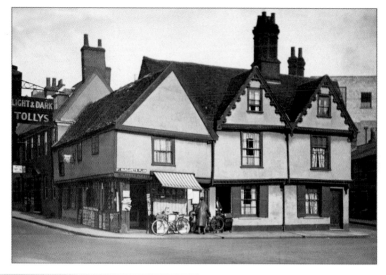

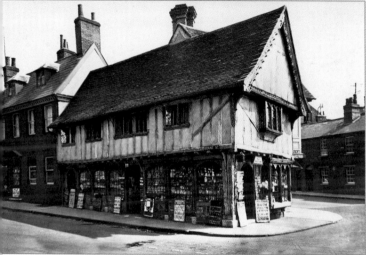

Soane Street, 1930s. The building was for many years a newsagent. The tiny terraced houses in the background were also replaced later in the decade.

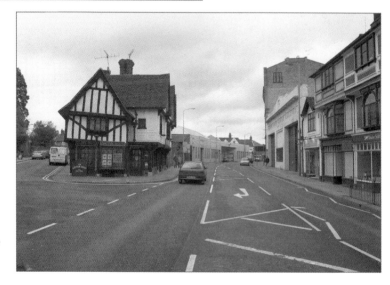

St Margaret's Street and Soane Street from St Margaret's Plain, 2004. The building is now home to Smith's estate agents.

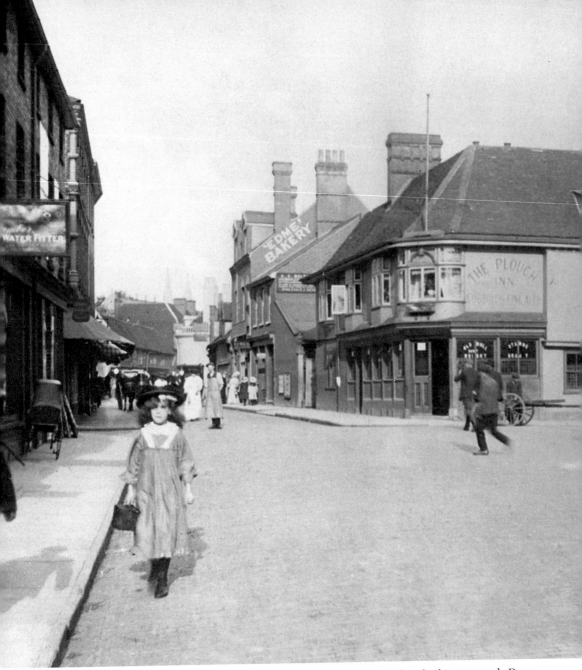

The Old Cattle Market, *c.* 1905. This picture postcard view was taken looking towards Dogs Head Street. The building of Charles Taylor, dealer in cart, van and wagon covers, coal and flour sacks, stood where the entrance to the bus station is. On the left of this view now is the Buttermarket Shopping Centre. The buildings in Dogs Head Street, including the Plough Inn, are much the same a century after this picture was taken.

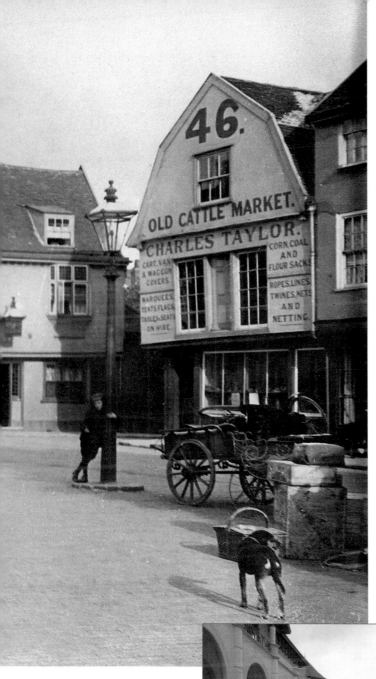

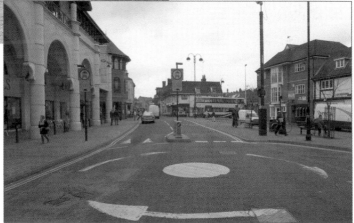

A 2004 image of the Old Cattle Market. The roof of the Coachman's Court building on the right of this view was badly damaged by fire in December 1990.

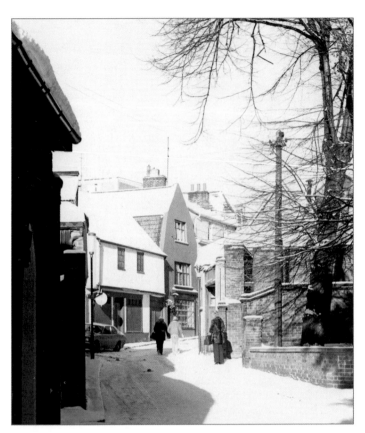

St Stephen's Lane in the winter snow of the late 1960s. This narrow lane from the Old Cattle Market to the Buttermarket has been transformed with the main entrance to the Buttermarket Shopping Centre now facing the open paved area in front of St Stephen's Church. The church is one of the town's oldest, built on a Domesday site. The present structure dates from the fifteenth century. St Stephen's is now used as the town's Tourist Information Centre. Several of the buildings close to the Buttermarket remain.

Below: St Stephen's Lane and Arras Square, with the steel and glass frontage of the Buttermarket Shopping Centre prominent, April 2004.

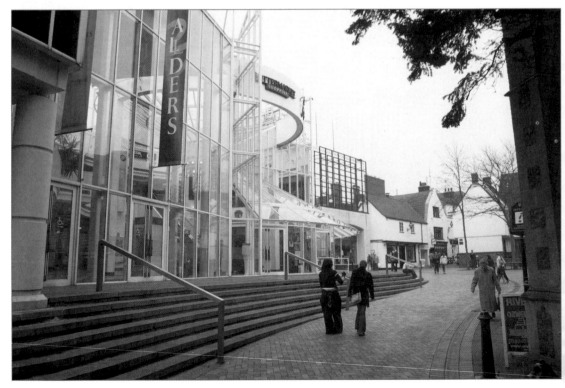

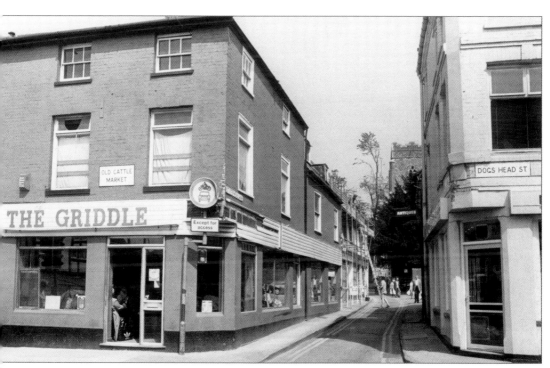

St Stephen's Lane from the Old Cattle Market, 1970s. The Griddle Restaurant and Kenyon and Trott's electro-plating works have been replaced by the Buttermarket Shopping Centre (below), which opened in October 1992. The tower of St Stephen's Church can just be seen above the tree.

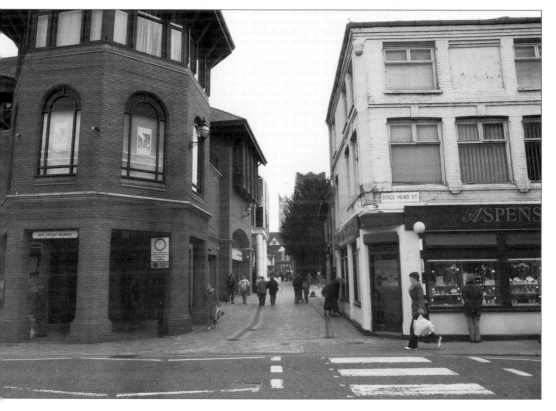

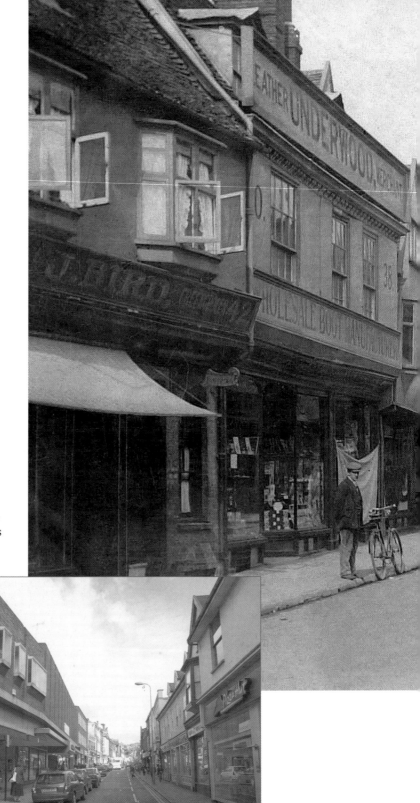

Below: The May 2004 view, with Sainsbury's store on the left.

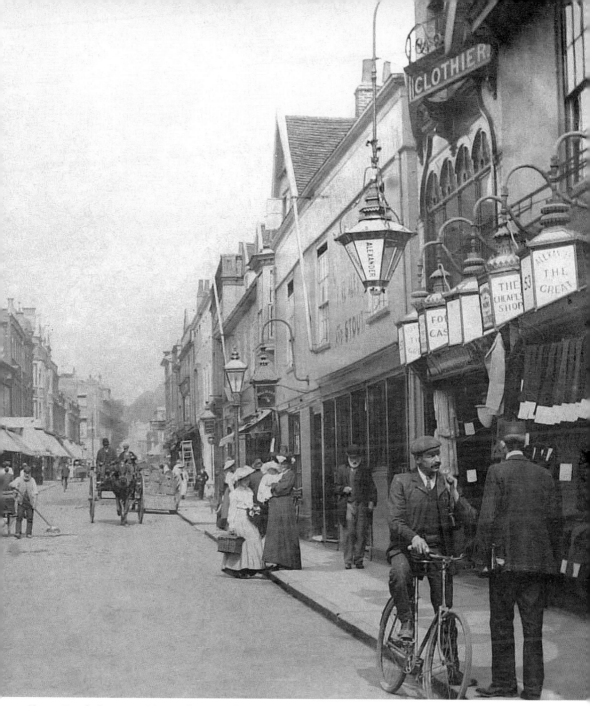

Upper Brook Street, c. 1905. The view from the junction of Tacket Street as it was in about 1905. On the left of the street are J. Bird greengrocers, and Underwood and Sons boot manufacturers, cycle retailers and bag merchants. On the right is the store of the Great Alexander, clothiers, with splendid gas lamps to light the window display after dark, the Fox Inn, G.H. Haddock the draper and the Coach and Horses hotel. The street is busy with elegantly dressed Edwardian ladies and men.

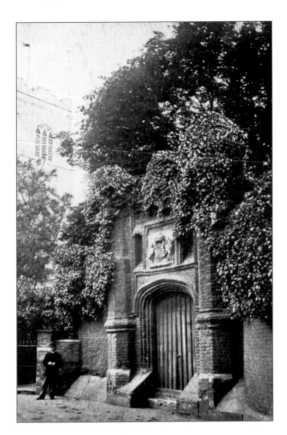

Wolsey's gateway in College Street, *c.* 1908. The tower of St Peter's Church can be seen in the background.

Below: College Street, April 2004. The street is now part of the town's busy gyratory system. Thousands of vehicles thunder past this historic site every day.

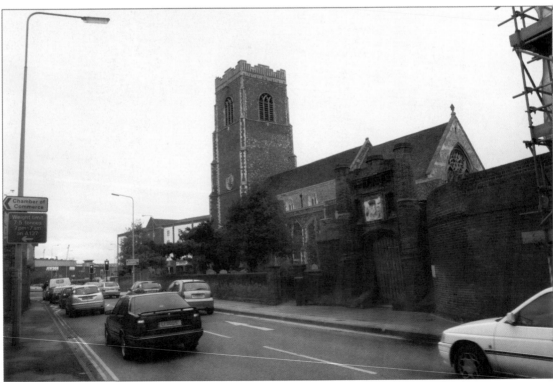

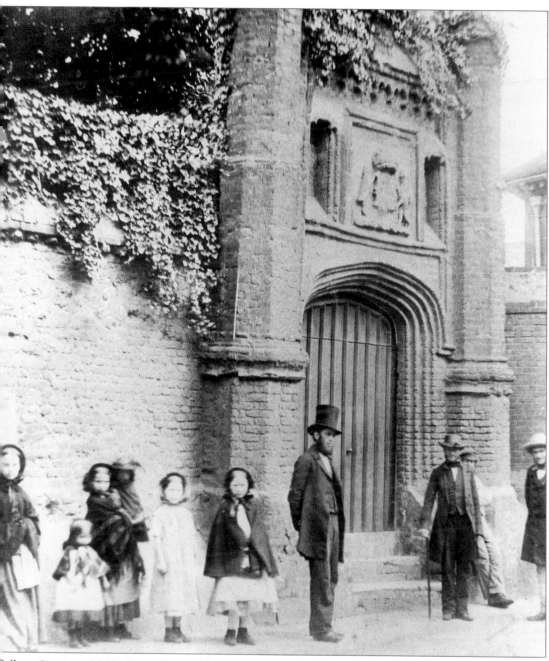

College Street, c. 1860. One of Ipswich's most famous sons is Cardinal Wolsey. All that remains of his planned college for the town of his birth is the gateway in College Street. The planned college was the largest of fifteen feeder schools for Oxford. In summer 1528 flint from Harwich and stone from Normandy was stockpiled in the parish of St Peter's Church. Wolsey planned to use St Peter's as the chapel of his new college. The foundation stone was laid in June 1528. Wolsey's fall from power saw the partially built college closed and the building materials seized by Henry VIII. Thousands of tons of flint and stone were moved to London for use on royal buildings. The gate would have been a route from the college directly to the quay on the River Orwell. This Victorian photograph was taken by Richard Dykes Alexander, a wealthy local banker and businessman, who was one of the first amateur practitioners of the then relatively new science of photography.

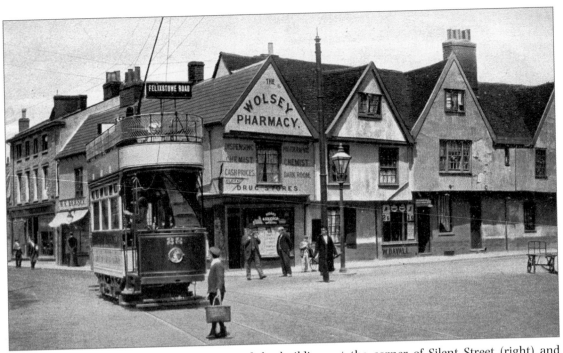

Silent Street, c. 1910. This postcard view of the buildings at the corner of Silent Street (right) and St Nicholas Street was taken from the corner of Cutler Street. It shows the building often referred to as Wolsey's birthplace. He was born near here in about 1475. This shows the building as it was before the timbers were exposed. It was then a pharmacy, which it remained until the 1970s. A plaque on the building today reads: 'Near this 15th century house on the opposite side of the way stood in 1472 the home of Robert and Joan Wolsey. Where the great child of honour Thomas Wolsey, Cardinal, Archbishop, Chancellor, passed his boyhood. In his power and pride he ranked himself with princes and trod the ways of glory. In his fall he died a humble man at Leicester Abbey about the hour of eight in the morning of November 29th 1530 and was buried at the dead of night.'

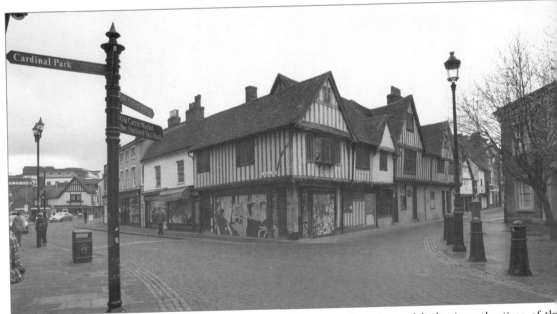

Silent Street, 2004. The building line in this part of the town has changed little since the time of th Edwardian view above. The area is now paved. It is a popular route from the town centre to th Waterfront and Cardinal Park area of town.

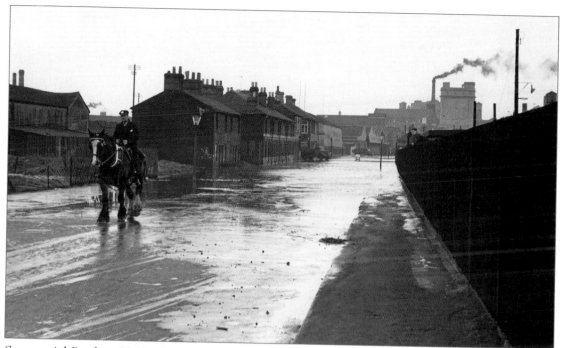

Commercial Road, *c.* 1950. This road, close to the River Orwell, was prone to flooding until new flood barriers were built to protect the area. In this picture a railway worker is riding a horse used for shunting trucks around the dock and in the rail-marshalling yard behind the fence on the right. In the distance silos at the dock are visible.

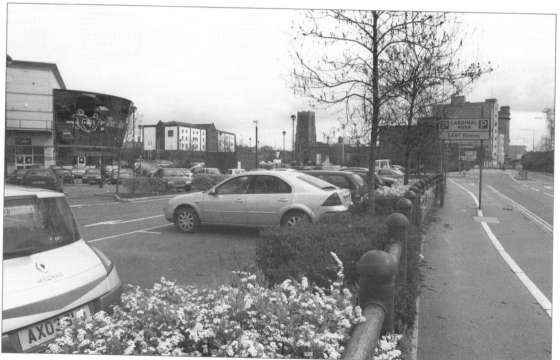

The Cardinal Park entertainment area dominates the scene today, where every day thousands visit the restaurants, cinemas and nightclubs. The road has been renamed Grafton Way.

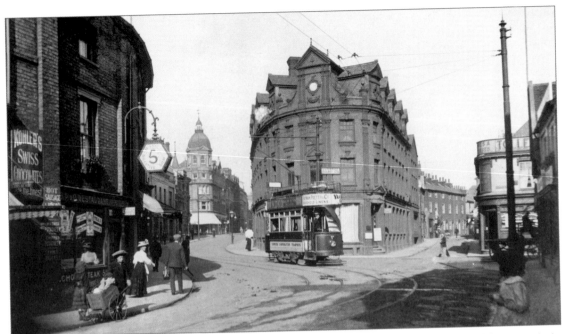

Prince's Street, *c.* 1910. One of the town's electric trams, which came into service in 1903, en route to the railway station. The large building in the centre at the junction with Friar's Street was the premises of Grimwade Ridley and Co., wholesale druggists. The dome-topped building in the distance was R.D. and J.B. Fraser's store at the corner of Museum Street. This building was destroyed by fire in April 1912. It was rebuilt in similar style and is now an insurance company's offices.

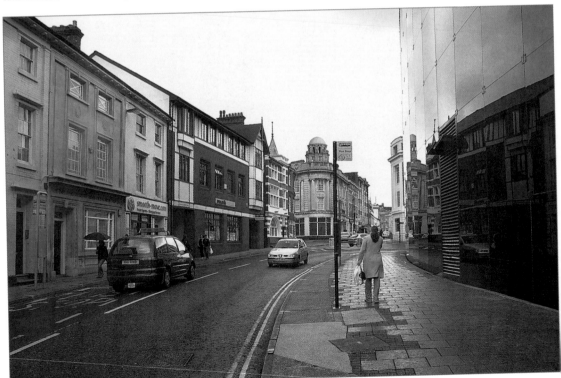

Prince's Street, April 2004. The glass-clad Willis insurance office now dominates the view.

Museum Street, featuring
R.D. and J.B. Fraser's store selling
house furniture, upholstery and
jewellery, *c*. 1890. A delivery
wagon is standing at the junction
with Elm Street.

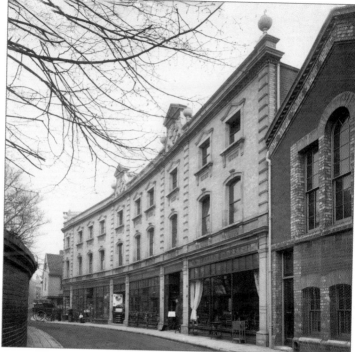

The scene of destruction at
Fraser's store after the fire in
April 1912. By this time the
buildings in the background had
been erected, where the brick
wall is on the left of the picture
above.

Museum Street, April 1904.

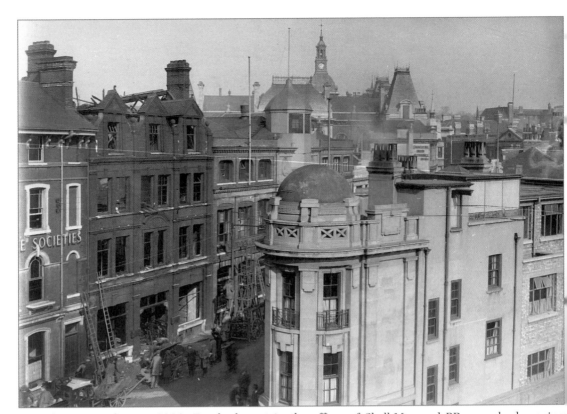

Prince's Street, February 1932. Fire broke out in the offices of Shell-Mex and BP, severely damaging the building. The blaze also damaged the premises of Haddock & Baines printing works next door. The printing works itself was destroyed by fire in February 1950, and this second fire also engulfed the Central Cinema. This high view was taken during the clearing-up operation.

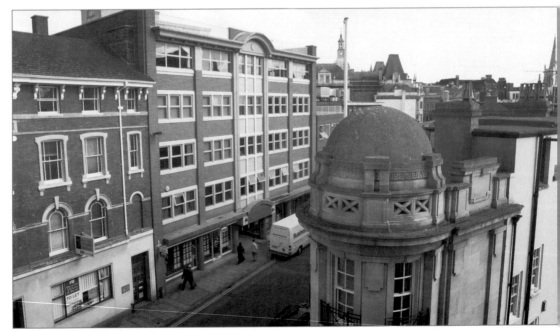

Prince's Street, April 2004. The street has seen many changes since the fire over fifty years earlier.

Tower Ramparts, *c.* 1890. The buildings on the right stand on the old town wall, which gives this part of the town its name. The building in the background was built in 1881 along the line of the wall. It was owned by Footman Pretty & Nicholson, drapers, silk mercers and stay manufacturers. A staff of around 1,500 worked there. The building closed as William Pretty & Sons in 1982. The building stood partly demolished until 1987.

The modern view with Tower Ramparts bus station on the right.

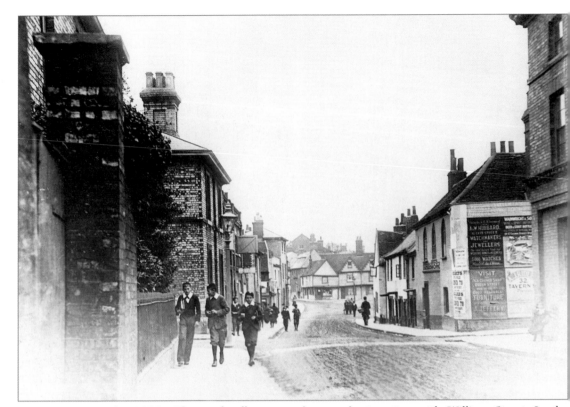

Crown Street in the 1890s. Three schoolboys are close to the junction with William Street. In the background is the building at the junction of Soane Street featured on p. 27. All of the other buildings seen here have gone. The Tower Ramparts bus station is now on the right of this view.

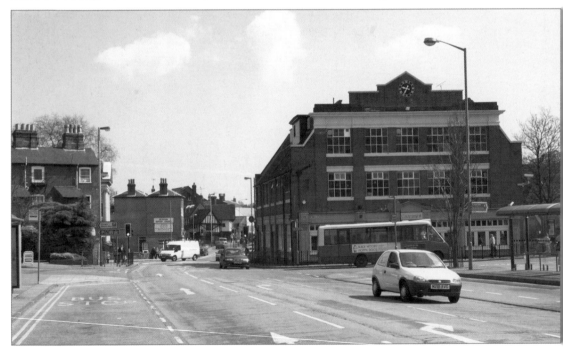

The view in 2004.

Old Foundry Road, 1890s. These houses in Old Foundry Road stood on the town ramparts. Philips and Pipers clothing factory, now Pipers Court, replaced some of them. The rest were removed for rebuilding during the 1930s. This picture is the work of photographer Harry Walters, whose studios were nearby, on St Margaret's Plain.

Old Foundry Road, April 2004. Pipers Court flats converted from the clothing factory are on the right.

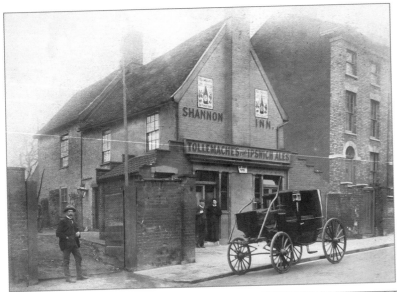

The Shannon Inn,
St George's Street, *c.* 1910.
These buildings are still
recognisable almost a
century later. Many of the
town's public houses have
closed; at this time
St George's Street had three.
The Globe was a few yards
away and the Rainbow
was on the corner of
St Matthew's Street.

This magnificent steam
lorry belonged to Talbot &
Company Ltd, whose
mineral water works were
in St George's Street.

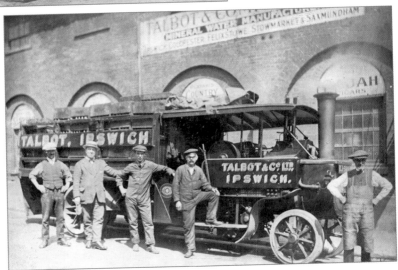

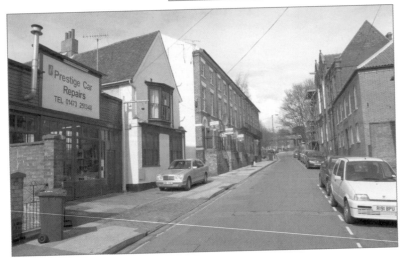

St George's Street, April
2004. The building which
used to house the Shannon
Inn has been a motor repair
and servicing business for
many years.

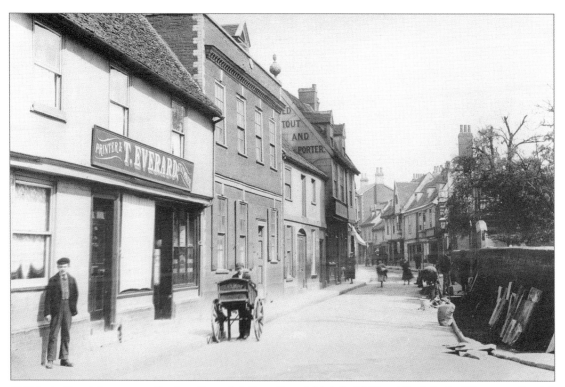

St Peter's Street from near the junction of College Street (right), 1890s. All of the buildings on the left were demolished in about 1900 to widen the road for the electric tram service route from the Cornhill to Bourne Bridge. The wall on the right encircles St Peter's churchyard. The buildings in the distance are still standing.

St Peter's Street, April 2004. Nearby is one of the town's busiest junctions, with a one-way system and double roundabouts feeding traffic around the Waterfront area.

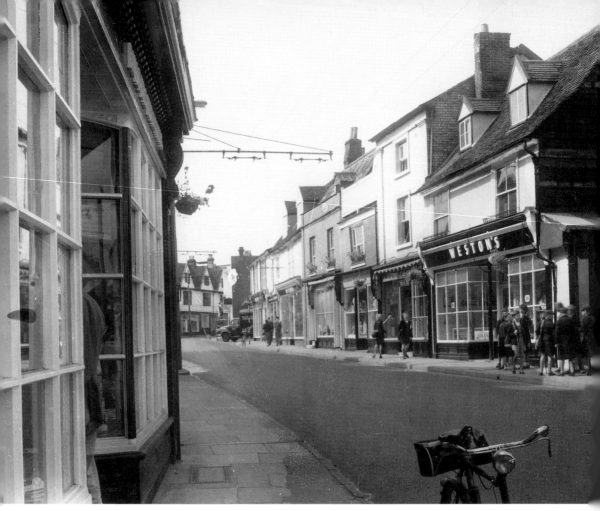

Fore Street from opposite the swimming baths, *c*. 1964. The shops from the right were Weston's Ltd radio and television, the Record Collectors shop, De Thame ladies' outfitters, Lucullus Café, Smyth Brothers, and George Gardiner, manufacturing confectioners.

Fore Street, April 2004. Several of the shops were knocked down to widen Angel Lane. Through traffic from Salthouse Street to Waterworks Street travelled past the swimming baths until the traffic scheme was altered and the route closed. This section of Fore Street, once the main route to the town centre from the east, is now closed to through traffic. A modern office building has replaced some of the shops.

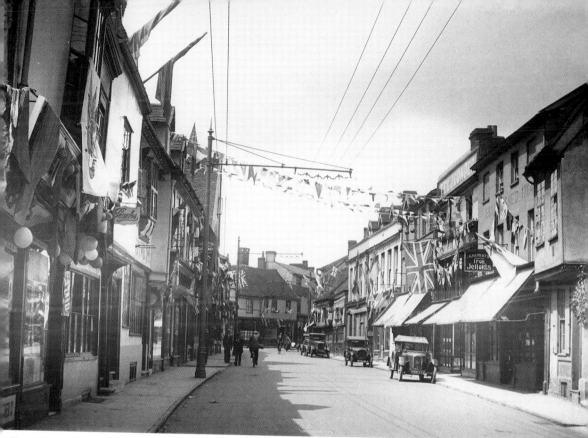

Fore Street, June 1930. This busy street was once full of shops and houses. It is now part of the one-way gyratory system taking traffic from the east around the Waterfront buildings. When this picture was taken, drivers were able to park outside a range of shops in the two-way street. From the left of the picture are W.R. Fletcher's butchers, Pearks' Dairy, Harry Driver pork butcher, the Neptune Inn, and Ernest Parker, grocer and confectioner. Near the junction with Salthouse Street there was Stanley Potter greengrocer, and George Fenner cycle maker. On the right there is Jackson's chemist shop, T.E. Conder leather goods, Smyth Brothers ironmongers, and the Lord Nelson Inn.

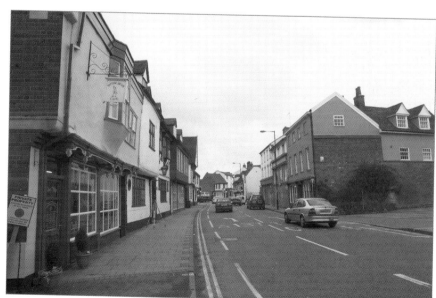

The only business which remains the same in this 2004 view is the Lord Nelson Inn, opposite Salthouse Street on the right. Some of the buildings on the right were destroyed by fire in July 1980.

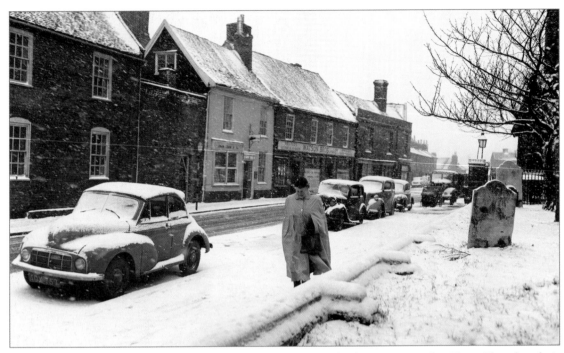

Elm Street, 1956. A view in the snow from the churchyard of St Mary at the Elms. The close-knit community of this part of town was lost when the tiny streets around Elm Street were demolished in the late 1950s and the area redeveloped during the 1960s. Some of the housing on The Mount, which was demolished, is seen in the background.

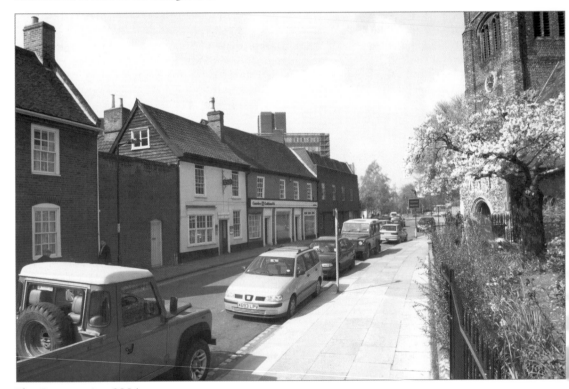

Elm Street, spring 2004.

Foundation Street, late 1950s. These fine houses were demolished in the mid-1960s. The land was used as a car park until a multi-storey car park was built in the late 1980s. Richard Felaw left the houses in the foreground at the junction of Little Wingfield Street to the Ipswich grammar school in the fifteenth century. In about 1612 the school moved from Felaw's house to the Refectory of Blackfriars nearby.

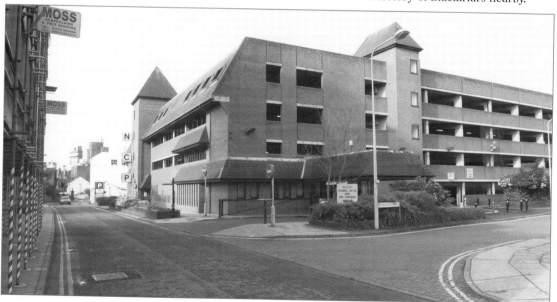

The multi-storey car park in Foundation Street, April 2004.

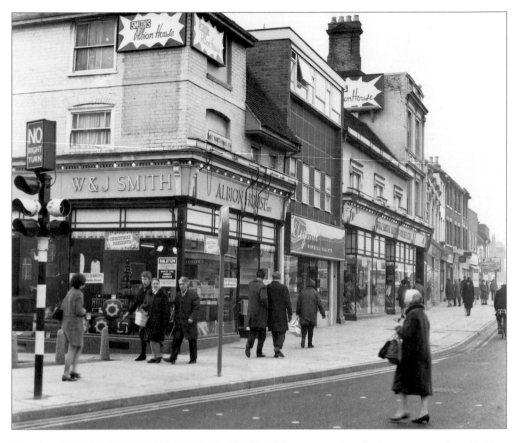

St Matthew's Street, December 1966. The buildings in the foreground have been replaced, including W. & J. Smith's Albion House store and the Bowhill Elliot shoe shop. Tesco opened a store on this site in 1969.

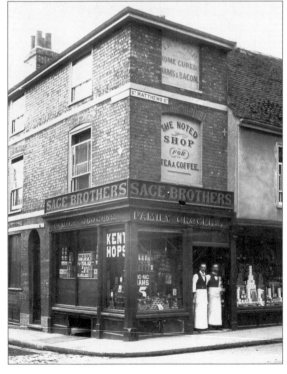

St Matthew's Street, c. 1915. Sage Brothers' grocery store was on the corner of St Matthew's Street and Lady Lane.

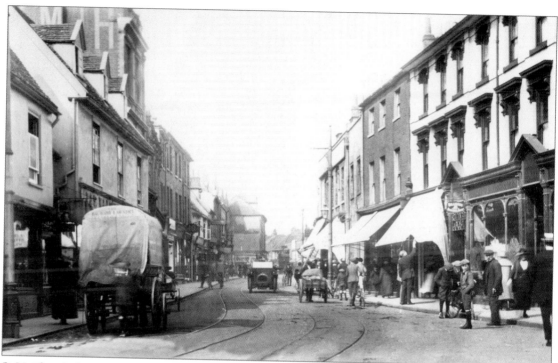

St Matthew's Street, *c.* 1918. The area was set for huge changes in the 1960s when the road was made into a dual carriageway. The north side of the street (right) from the junction with Crown Street to beyond Berners Street was demolished to widen the road. The Rainbow public house is at the corner of St George's Street on the right.

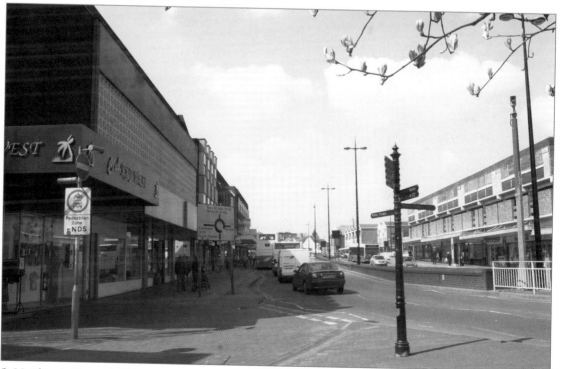

St Matthew's Street, 2004.

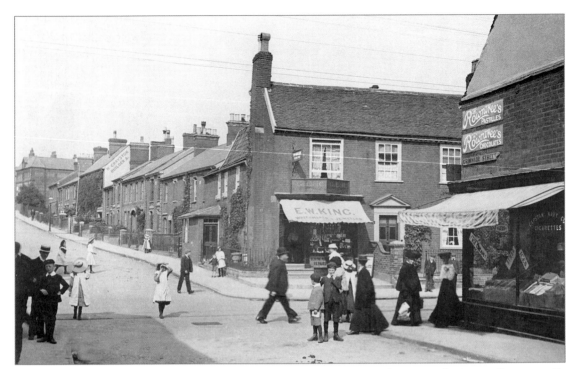

The crossroads of Argyle Street (background), St Helen's Street and Grimwade Street (foreground), *c.* 1910. There was so little traffic at this time that children were able to play in the street. All of the buildings at the corner of Argyle Street and St Helen's Street were demolished in the 1950s. Wells Court flats now stand on the site. E.W. King's watchmakers and jewellers is facing the camera. The shop on the right is still a newsagent's around ninety years later.

The busy junction is now controlled by traffic lights, April 2004. Wells Court is in the centre.

St Helen's Street, *c.* 1905. The County Hall, with its castle-like façade, was home to the Suffolk County Council until spring 2004 when the council moved to new offices at Endeavour House, near Ipswich Town Football Club. The county gaol was behind this building until closure in June 1925. The last execution on this site was on 27 November 1924. The last public hanging was in St Helen's Street, at the junction of Orchard Street, on 14 April 1863. Both men were hanged for murder.

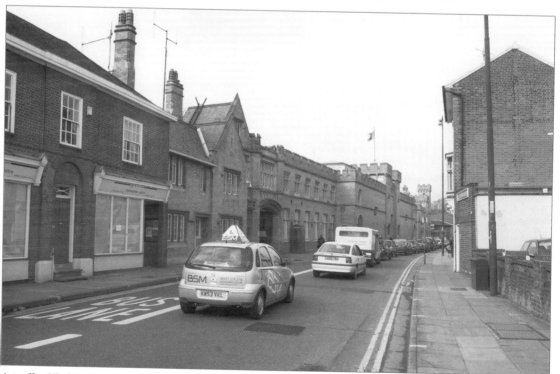

A traffic-filled St Helen's Street, 2004.

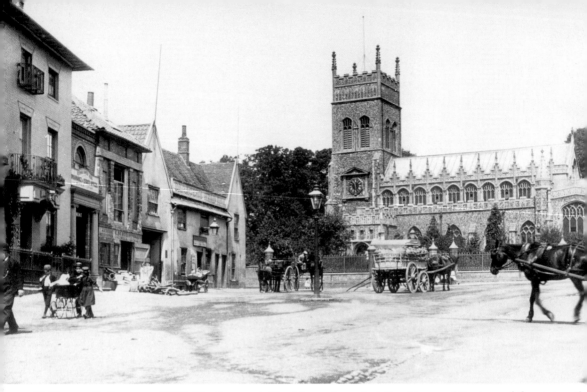

St Margaret's Green, *c.* 1900. The Saracen's Head Inn, characteristic of inn architecture of the sixteenth century, at the corner of Soane Street, was a popular stop-off point for farmers and their workers as they travelled to and from the north side of town. A horse and wagon are pulling away from Cobbold Street on the right as children push a pram towards the town centre. The fifteenth-century St Margaret's Church and the buildings around have changed little as a century has passed. The building centre left with materials outside was then the premises of Ephraim Scott, engineer.

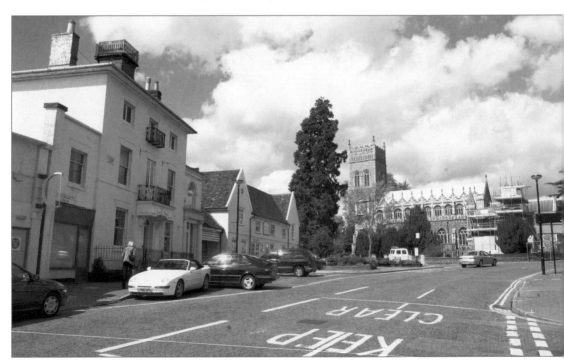

St Margaret's Green, April 2004.

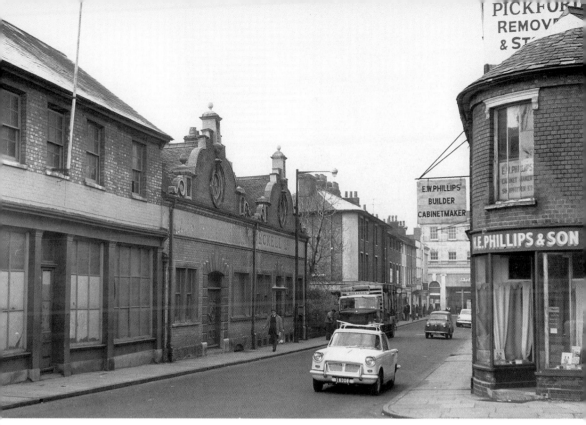

Great Colman Street, mid-1960s. The premises of Rands & Jeckell, tent makers, are on the left, and were standing empty awaiting demolition, as the whole area through to Carr Street was cleared for the building of the Carr Precinct, later renamed the Eastgate Shopping Centre. On the right at the corner of Old Foundry Road are the premises of H.E. Phillips & Son, motor and general engineers, and E.W. Phillips, builder and cabinetmaker.

Great Colman Street forty years later.

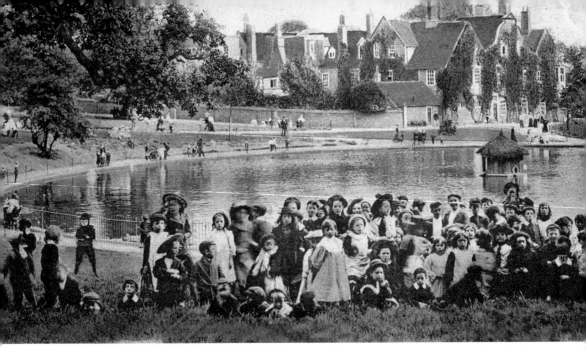

Christchurch Park, *c.* 1905. A group of children huddles by the round pond with the ivy-covered Elizabethan mansion in the background. Amazingly when the park was offered for sale in 1892 a poll of ratepayers rejected the purchase. Land around the edges of the park was sold for housing, and the town council acquired the greater part of the park. Felix Thornley Cobbold bought and presented the mansion to the town. The park opened to the public in 1895.

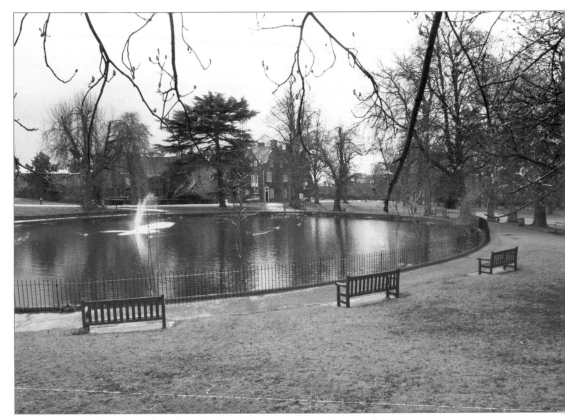

The round pond in Christchurch Park from the same viewpoint, April 2004.

2

The Dock & Waterfront

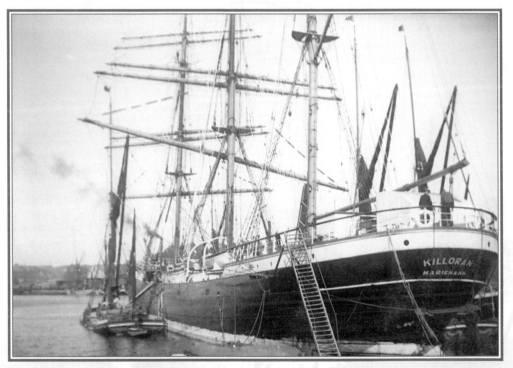

The cargo sailing ship *Killoran* in the dock, *c.* 1936. Huge sailing ships were a common sight in the dock until the 1930s. Sadly this fine ship was sunk in August 1940 by German action. The crew were taken prisoner and the vessel sunk by explosive charge. She sank with her sails set.

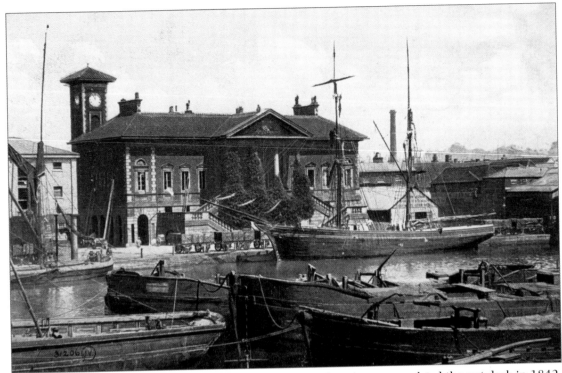

Wet Dock, *c.* 1912. With great vision Victorian planners and engineers completed the wet dock in 1842. The tidal flow of the River Orwell had been redirected by cutting a channel, the New Cut, and damming the river to form a dock covering 33 acres. This was the largest area of water of its kind in the country at the time. The Custom House featured in this photograph was built in 1845 at a cost of £4,250. It was designed by John Medland Clarke, who won a competition to design the building. He was a local architect who died in 1849 aged thirty-six.

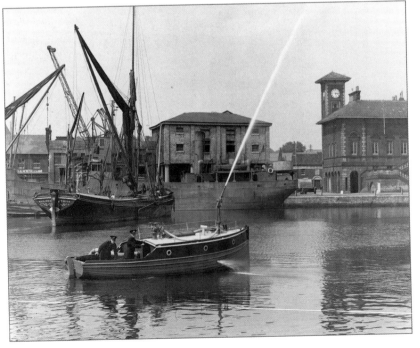

Wet Dock, 1940. Firefighting equipment during the Second World War was primitive. This National Fire Service float was photographed during a training session early in the war. It was sunk in a bombing raid on the night of 9/10 April 1941, when a member of the crew was killed. In the background is the Custom House (right). On the extreme left behind the Ipswich barge *Marjorie* is the public house, the Union Jack.

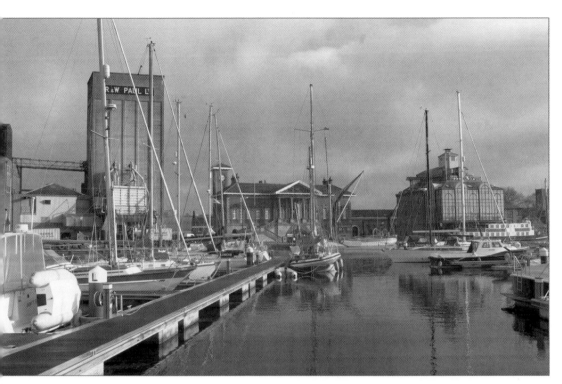

The dock has expanded into a leisure area as the Waterfront. Yachts, apartments, offices and restaurants have taken over the traditional port work.

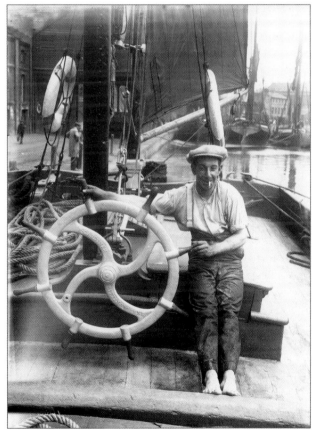

Wet Dock, *c.* 1930. A barefoot barge hand, complete with cloth cap and cigarette, is seen on board a grain barge in front of the Custom House.

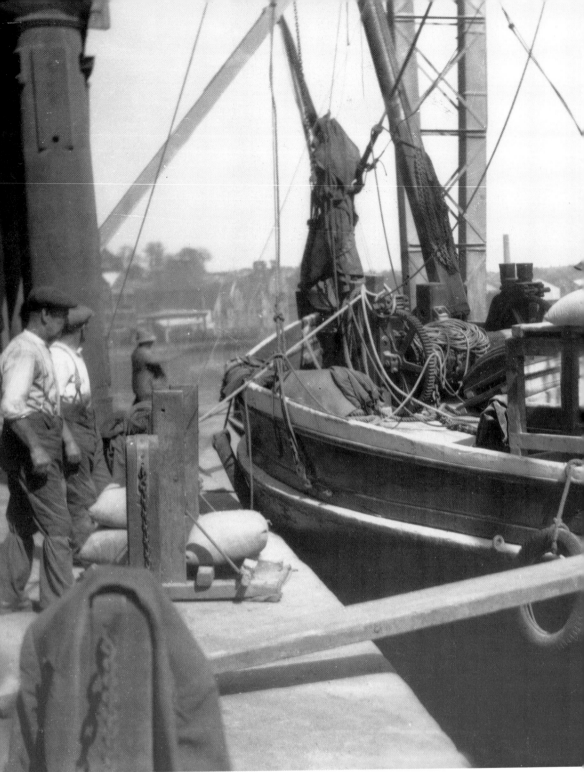

Wet Dock, *c.* 1930. Grain clippers from Australia and the West Coast of America brought their loads to the mills of Ipswich until the late 1930s. The largest of these were unloaded on to barges at Butterman's Bay, near Pin Mill, to reduce their draught to allow them to enter the dock where the rest of the grain was unloaded. This barge is near the Cranfield's and Paul's silos.

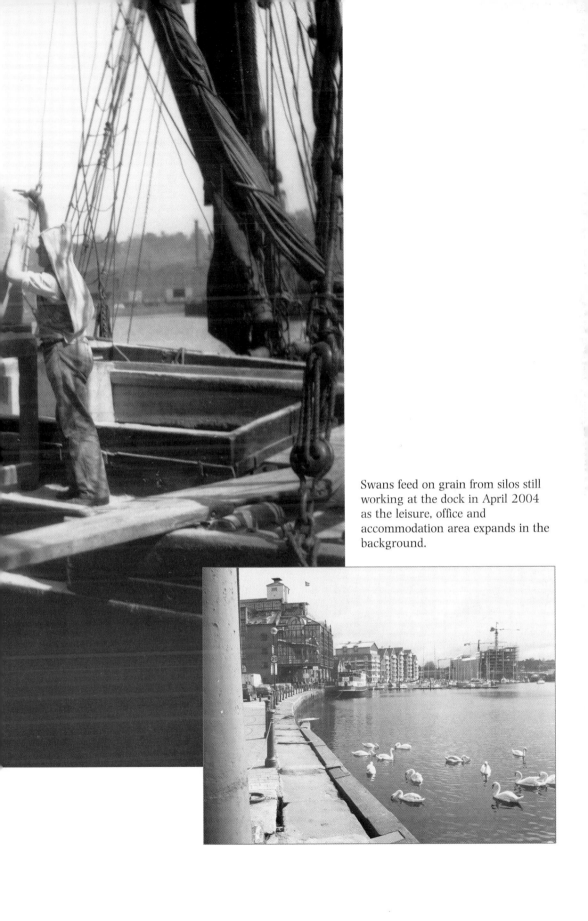

Swans feed on grain from silos still working at the dock in April 2004 as the leisure, office and accommodation area expands in the background.

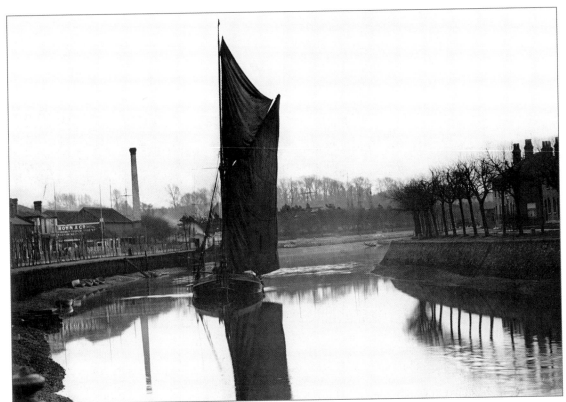

Trees lined much of New Cut when this picture was taken in about 1904, and it was a popular leisure area until industrial development took over in the 1920s.

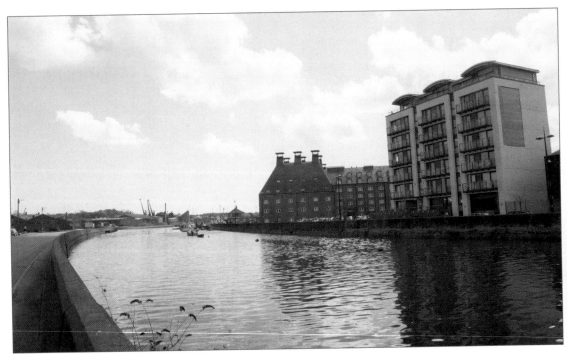

New Cut a century later from the same viewpoint, April 2004.

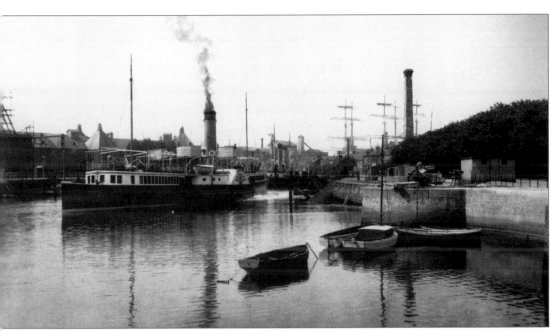

New Cut, *c.* 1910. Three paddle steamers, the *Norfolk*, *Suffolk* and *Essex*, belonging to the Great Eastern Railway Company, ran a passenger service to Harwich and Felixstowe from about 1905 to 1930. The electric tram service ran from along Bath Street providing transport for passengers from the railway station to the boats via the Cornhill. There was a ticket office at the Steam Boat Tavern on New Cut West. The original lock into the dock was from New Cut. The entrance is clearly visible on the right of both of the photographs on this page. The location of the lock made it difficult for a ship to turn in the dock, so the lock was moved to its present site, and this solved the problem. With great ceremony it was opened on 27 July 1881.

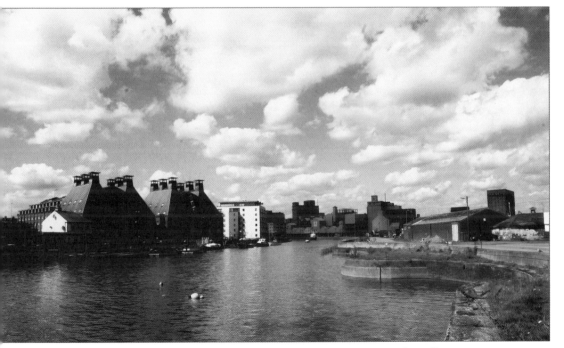

New Cut, April 2004. On the left is the Felaw Street Maltings, now converted to offices.

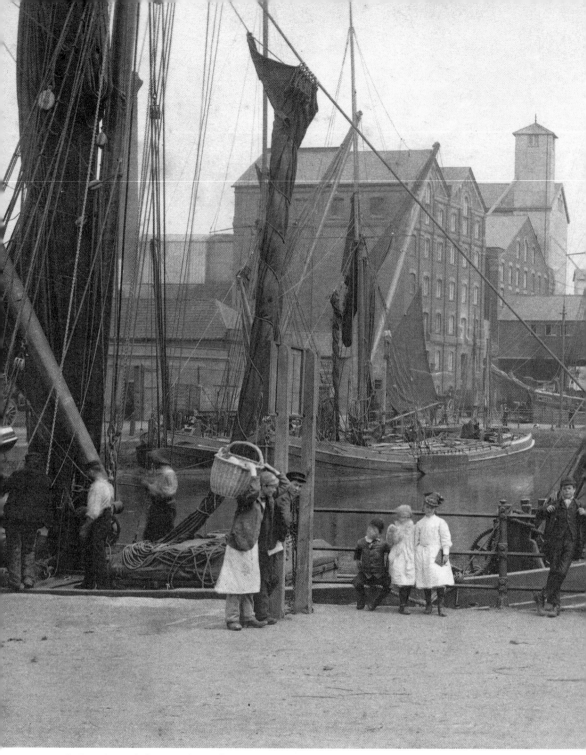

St Peter's Dock from Stoke Bridge, *c.* 1890. New Cut is off to the right of this view. The silos and warehouses in the background are set for redevelopment for leisure and accommodation. This photograph was taken by Ipswich photographer William Vick and published as set of real photographs mounded on card, some in leather-bound volumes as *Ipswich Past and Present.*

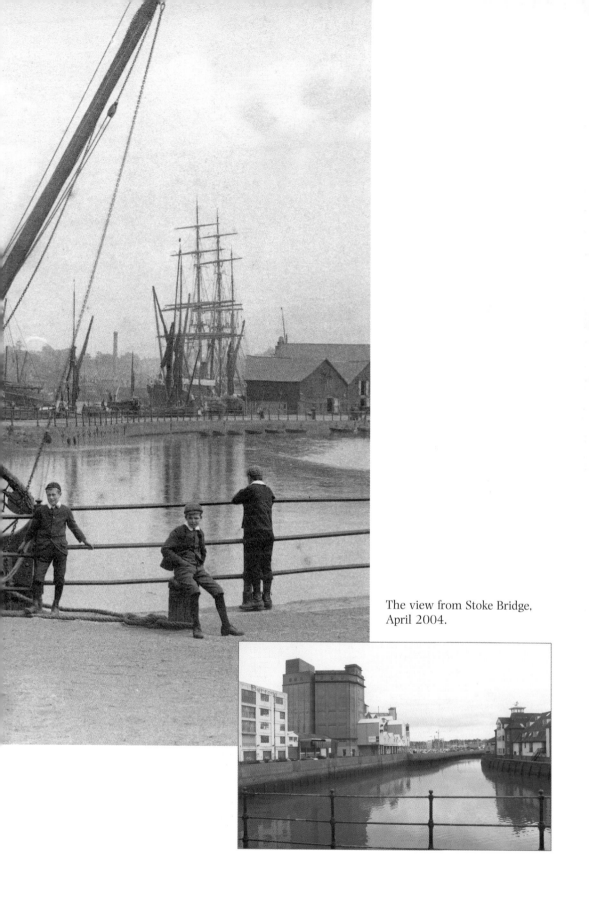

The view from Stoke Bridge,
April 2004.

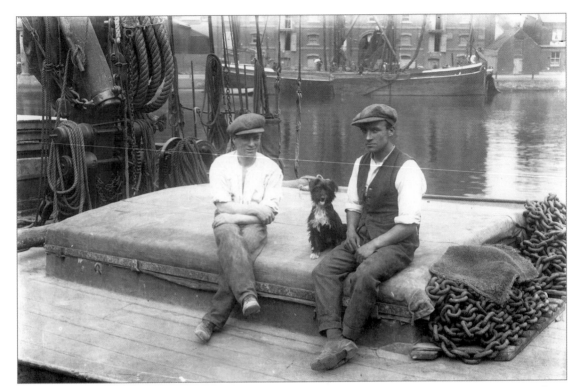

Wet Dock, *c.* 1930. This pair of barge hands posing with their dog in about 1930 would never have dreamt that the site of their hard work would one day be filled with expensive leisure craft and the dock turned into a marina.

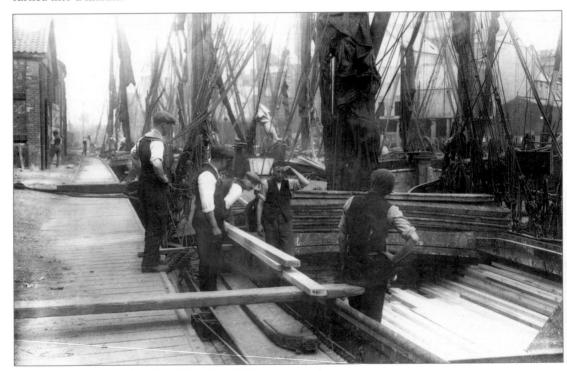

Timber being unloaded at Flint Wharf, *c.* 1930.

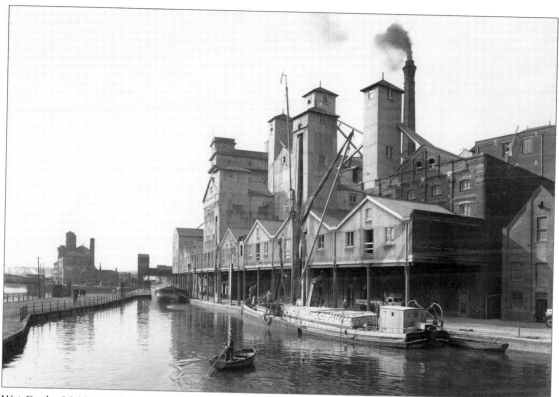

Wet Dock, 1949. Smoke billows from the chimney at Cranfield Brothers Ltd flour mill. A grain-loaded barge is tied up at the quay. On the extreme left in the background is Stoke Bridge.

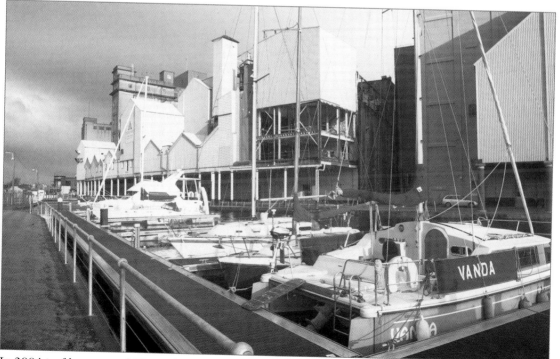

In 2004 turf has covered Flint Wharf as the Cranfield's site awaits redevelopment in the background.

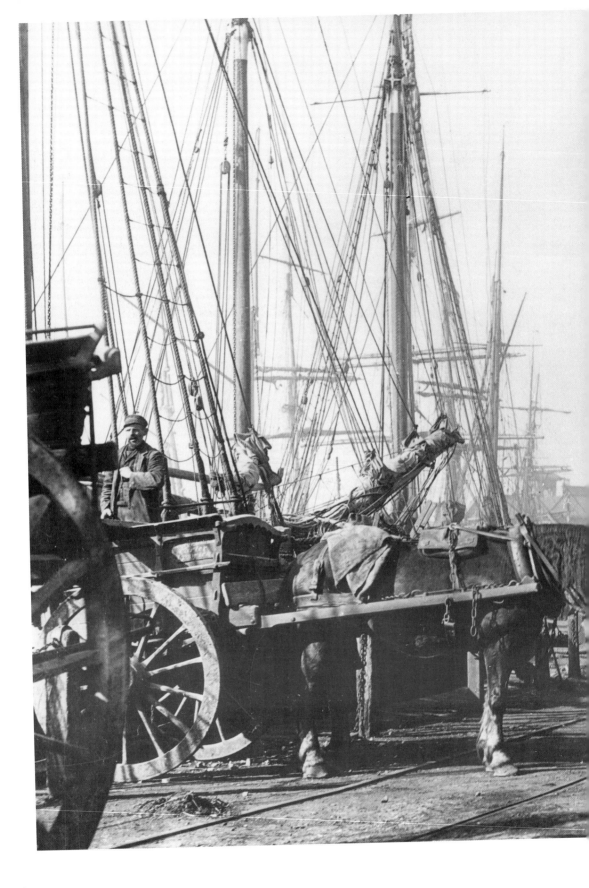

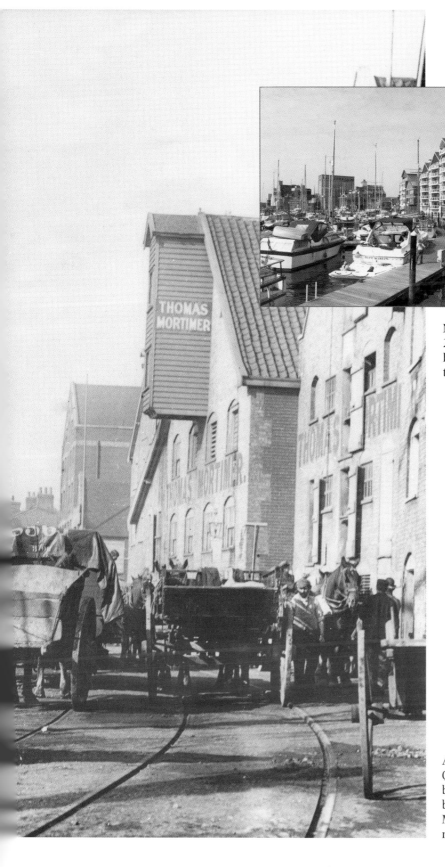

Neptune Quay, April 2004. Modern flats have replaced the busy trading site.

A packed Neptune Quay, *c.* 1890. The buildings on the right belonged to Thomas Mortimer, corn merchants.

Key Street, 1950. These ancient buildings in Key Street were in poor condition when the decision was taken to demolish them in 1951. No doubt they would have been restored in more recent years. The Bull Inn, behind the Custom House, is on the extreme right of this view by the telegraph pole. The inn dates from the sixteenth century. The old quay near the Bull was where a resident of the parish of St Clement's, Thomas Eldred, sailed with Thomas Cavendish on a two-year expedition in 1586. Cavendish, from Trimley St Martin, led a fleet of small ships round the world, second to Sir Francis Drake. The former inn is now converted to flats.

The Bull Inn was a Cobbold public house when this picture was taken in the late 1940s.

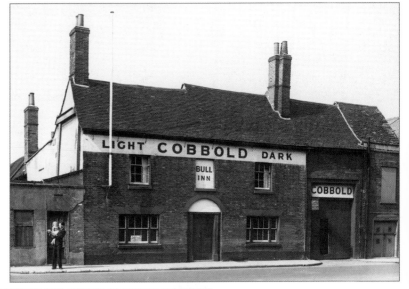

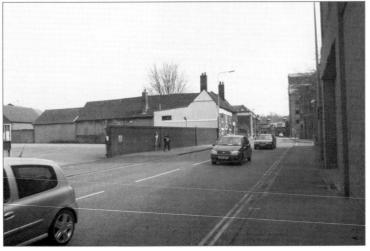

The Bull Inn now stands isolated in Key Street. The building was hit by a German Zeppelin raid on 31 March 1916. A bomb destroyed part of the roof and demolished an adjoining cottage, killing a man. Cobbold's bonding vault and the nearby Gun Inn were also damaged.

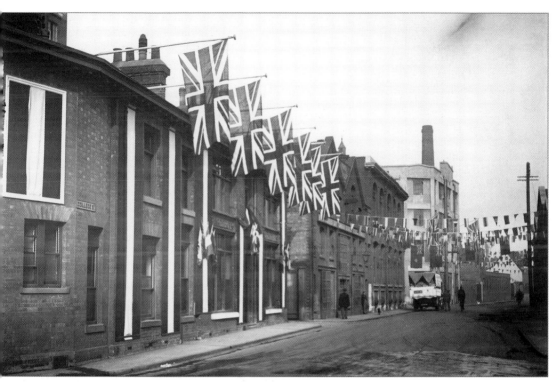

College Street, June 1930. The flags were flying when the Prince of Wales came to town to perform the official opening of the town's new airport. Burton Son & Sanders Ltd, wholesale grocers and provisions merchants, occupied most of the buildings in this picture.

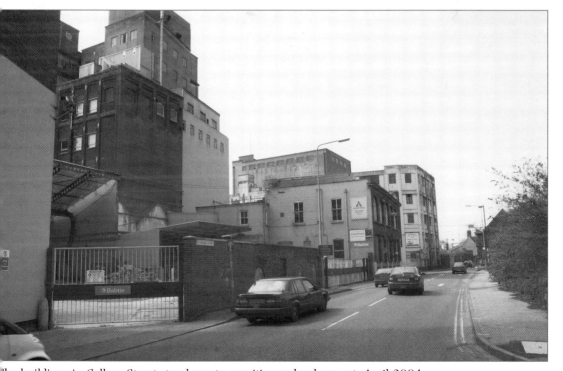

The buildings in College Street stand empty, awaiting redevelopment, April 2004.

Wet Dock, 1930s. This view was taken from one of the holders at the town's gasworks, part of which is in the foreground of the photograph. The whole area was then industrialised. Beyond the gasworks the masts and sails of barges are seen along the quay where Ransomes Sims & Jefferies engineering works were until the mid-1960s. Rail trucks are lined up on the island site to the left. Stacks of timber stand by the warehouses of William Brown's timber merchants. On the far quay is the Custom House, featured in the photographs on pp. 58 and 59. On the extreme left are the grain silos and works of R. and W. Paul and Cranfield's, featured on p. 67. In the distance is the town centre.

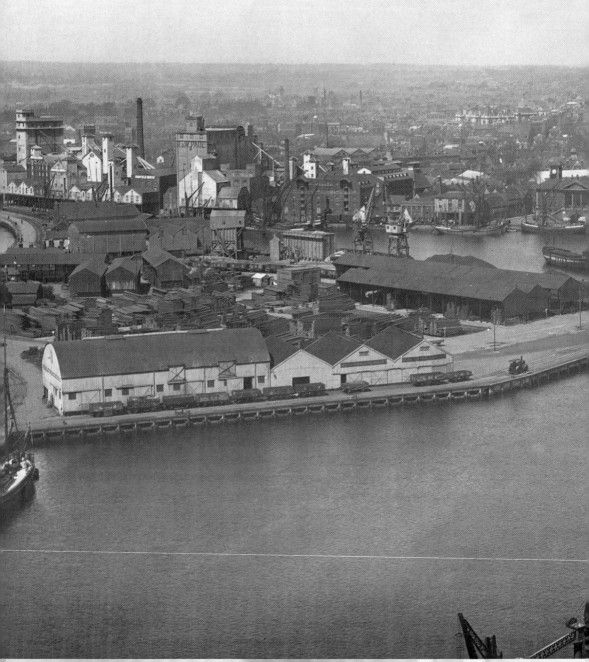

The Waterfront, as the dock has been renamed, from above the Suffolk College. The island site is at the top of this view. Yachts and pleasure craft have largely replaced barges and cargo ships.

The apartments and flats facing Neptune Quay (see p. 68) are in the foreground at the end of Grimwade Street. St Clement's Church is in the bottom right.

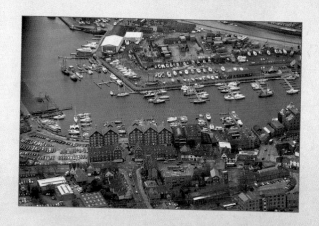

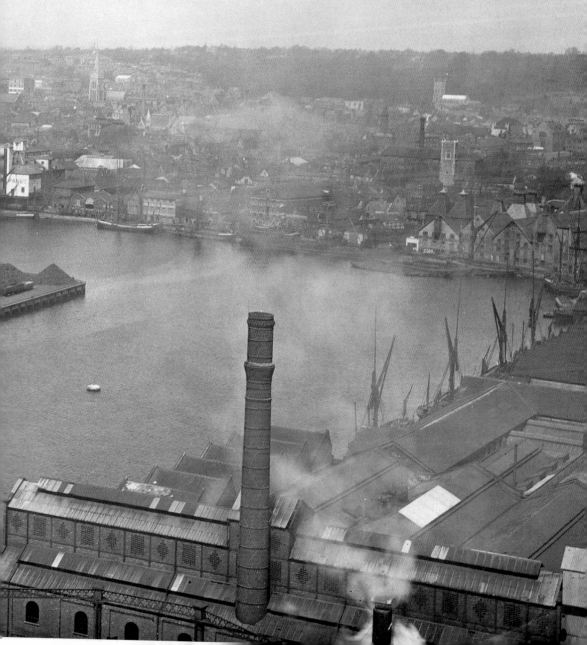

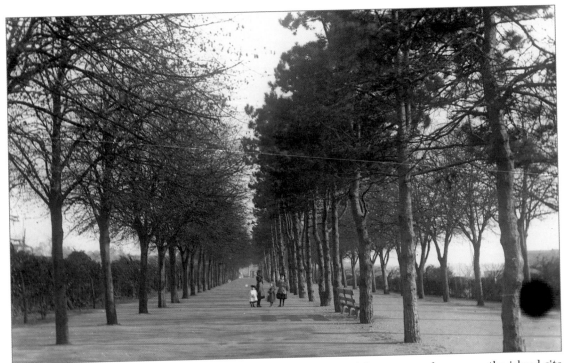

Promenade, *c.* 1900. These lines of lime and fir trees were part of the promenade area on the island site at the dock. This photograph was taken looking downriver with New Cut to the right and the dock to the left. Behind the children at the end of the trees was a shelter, known, because of its shape, as the Umbrella. Most families then did not have any means of transport and the area was popular for a day out by the river, as it was so close to the town centre. The trees were removed and the area industrialised in the late 1920s.

The promenade area has changed beyond recognition. This image from the same viewpoint shows how much industrialisation has affected this part of town.

3

Around the Town

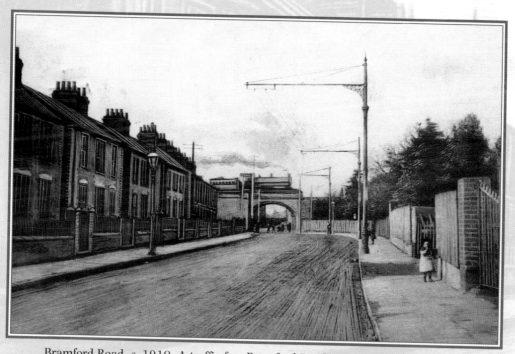

Bramford Road, *c.* 1910. A traffic-free Bramford Road with a train on its way to Westerfield station passing over the Victorian brick arch bridge. The arch was replaced in the 1960s by a steel one to improve the traffic flow.

Cemetery Road, 1910. This group – mainly women and children – is at the corner of Cemetery Road and Finchley Road. The pinafores and aprons were worn by women to keep their clothes clean while doing the daily household chores. Most had two or three, keeping the best white ones for special occasions.

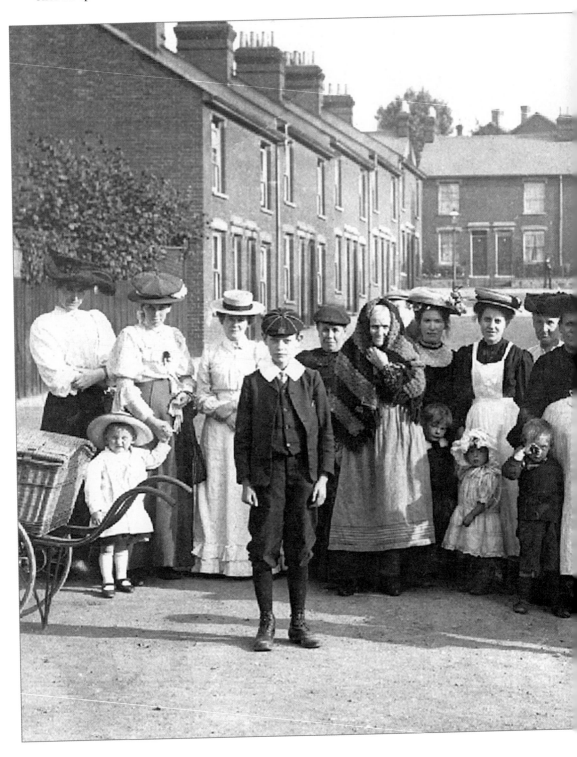

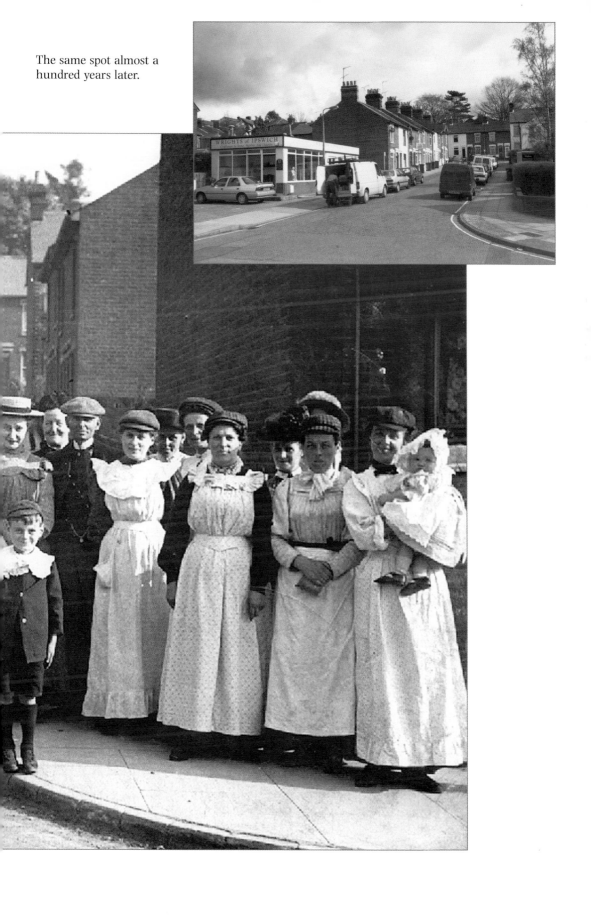

The same spot almost a hundred years later.

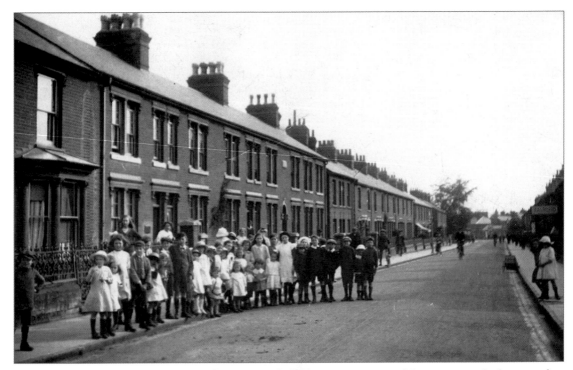

Cemetery Road, 1910. This image of a group of children was captured by a postcard photographer touring the streets. Many of the houses in the background were destroyed during the Second World War when a parachute mine landed on 21 September 1940. The mine could not be safely moved from the area and was detonated where it lay by a Royal Navy bomb disposal team. The explosion left a huge crater, destroyed seventy-five houses and damaged hundreds more.

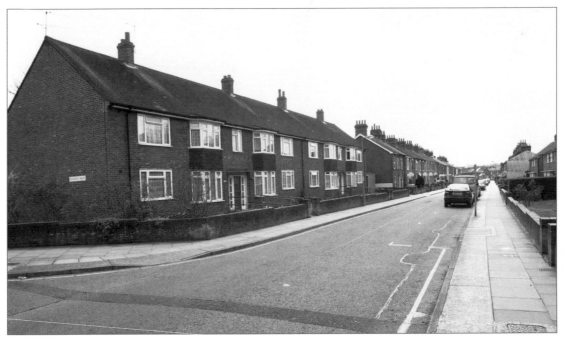

Cemetery Road, April 2004. The Victorian terraced houses behind the children in the picture above was destroyed in September 1940. They were replaced in the 1950s by the present housing.

Norwich Road from the junction
with Bramford Road, *c.* 1915.
The line of buildings along this
busy street has changed very little
since the time of this photograph.

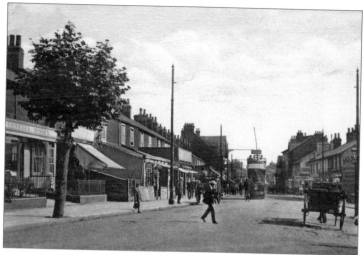

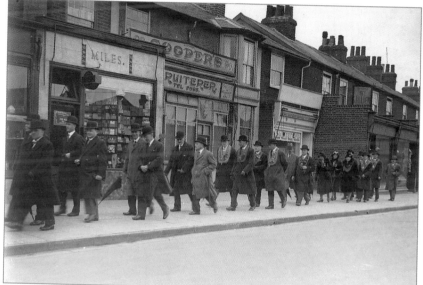

A parade passes by
the small shops on
Norwich Road. This
undated photograph
is probably from the
1930s when Edward
Miles had his
tobacconist's shop on
the left.

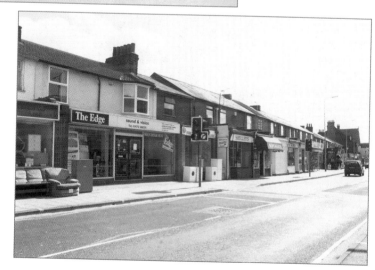

The same part of Norwich Road,
April 2004. It is still mainly filled
with small shops and houses.

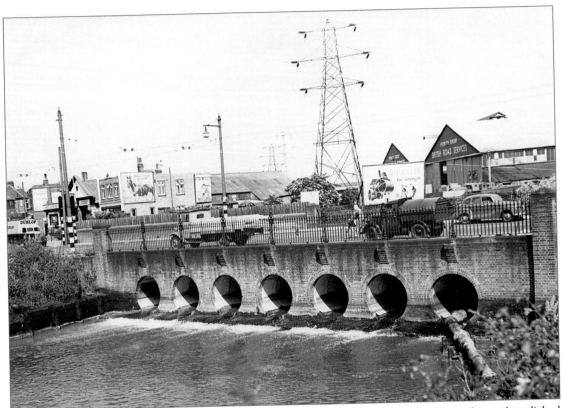

London Road, 1950s. The Seven Arches Bridge across the River Orwell at London Road was demolished in May 1959. The bridge once stood beyond the end of the built-up area in open countryside.

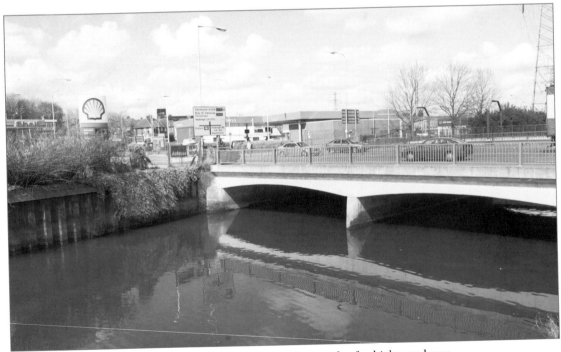

The modern bridge over the River Orwell now carries thousands of vehicles an hour.

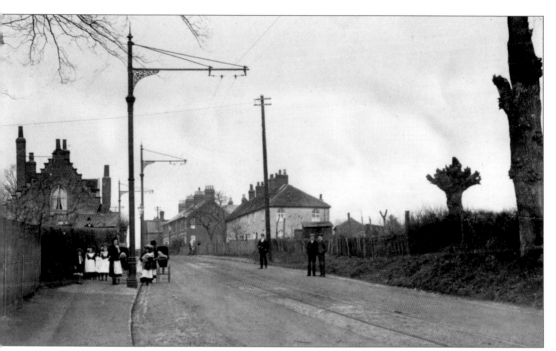

Whitton, *c.* 1904. Whitton was a tiny village, 2½ miles from the town centre, at this time. The electric tram service, which started in 1903, terminated outside the Maypole public house. Life changed for the population of around one hundred and thirty people in this close-knit community when they were able to travel to town cheaply and quickly. The village way of life was lost forever when the town expanded during the 1920s and '30s and the Whitton council housing estate was built, swallowing up the village. In this picture children are able to stand in the road and watch the photographer at work.

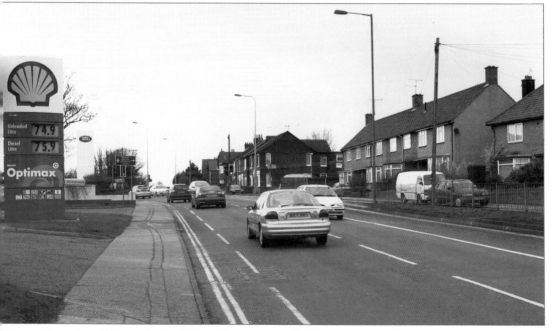

The modern view of Norwich Road from the junction of White House Road, April 2004. The terrace of houses in the background helps to locate the scene.

Whitton, c. 1904. Whitton to most people in Ipswich is the large housing estate on the north-west side of town. The estate was built on open land in the 1920s and '30s. It swallowed up the tiny village from which it took its name. Most villagers worked on nearby farms. This group of children is outside one of the village shops run by Mr Self.

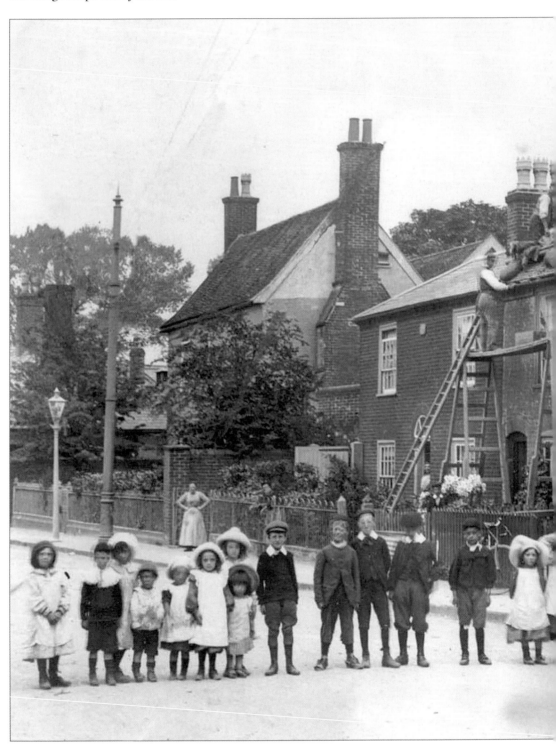

One hundred years later and the old part of Whitton has changed very little.

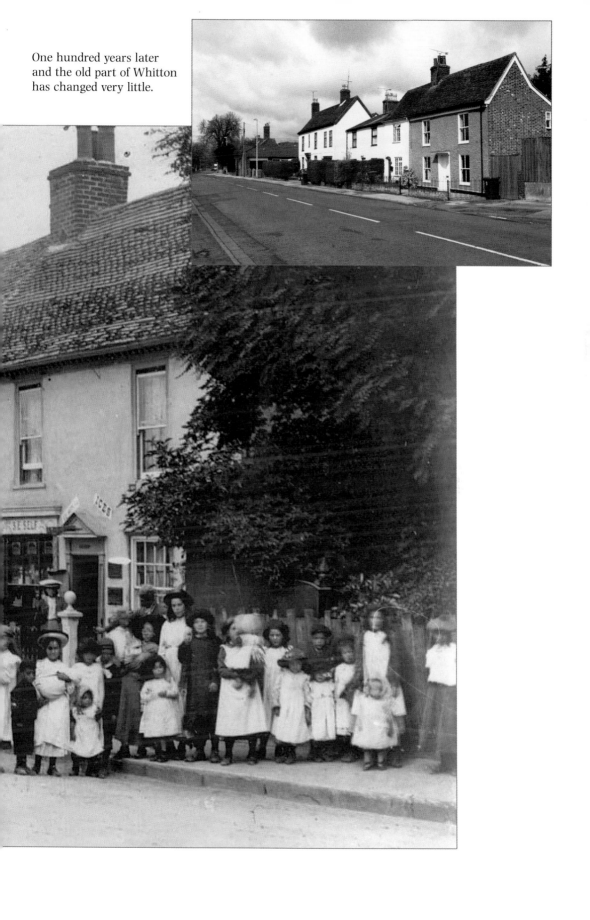

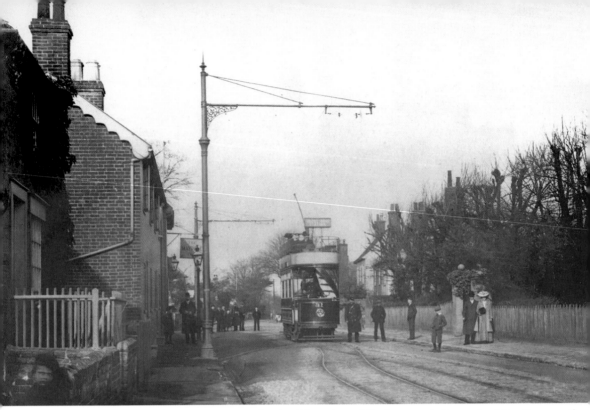

Whitton, *c.* 1904. An electric tram outside the Maypole public house, at the end of the line on the service along the Norwich Road from the Cornhill.

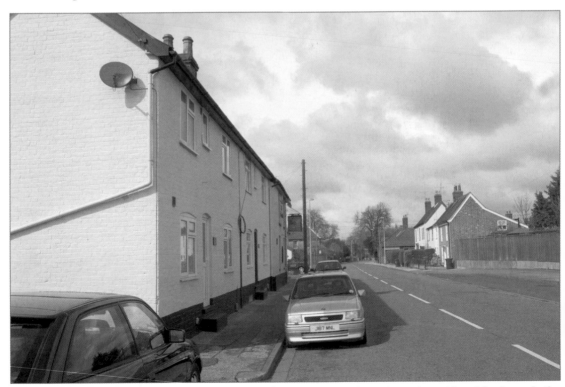

The Old Norwich Road, April 2004. What was the main route from Ipswich to Norwich through the village of Whitton has been bypassed, removing much of the traffic.

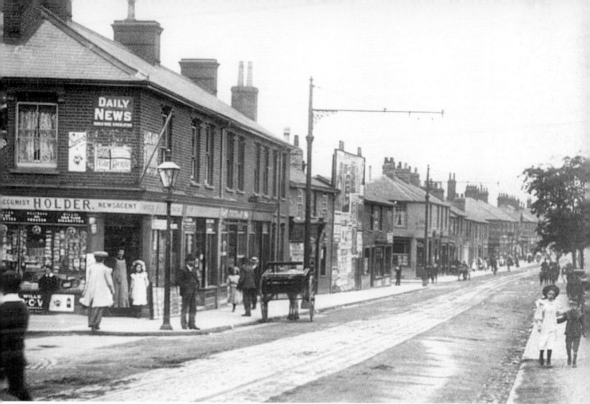

Bramford Road, *c*. 1912. Small shops served the local community in the packed side streets. The shop on the left is Holder's newsagent at the corner of Rendlesham Road.

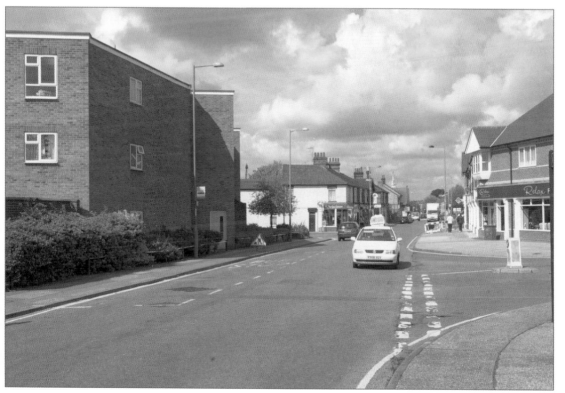

Many of the buildings and small shops in Bramford Road have been demolished in 2004.

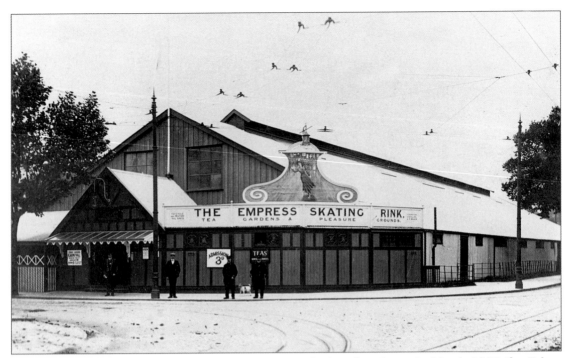

Portman Road, *c.* 1910. Roller-skating was popular with the Edwardians. In March 1909 the Palace Roller Skating Rink opened on the site of the former Provision Market near the Old Cattle Market. When it closed in 1920 the post office sorting office was built on the site. A second roller-skating rink, the Empress, opened in 1909 at the corner of Portman Road and Portman's Walk (now Sir Alf Ramsey Way). Three thousand people attended the opening ceremony. The Empress had tea-rooms and an orchestra, and admission was 3*d*.

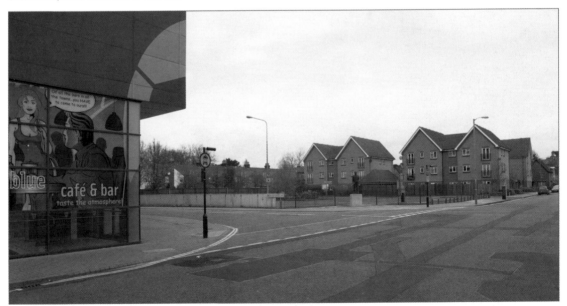

A statue of Sir Alf Ramsey, by Sean Hedges Quinn (known as 'Coach'), now stands on the corner of Portman Road overlooking the club's ground, April 2004. Manager Alf Ramsey led Ipswich Town Football Club to the division one championship in the 1961/62 season and England to win the World Cup in 1966. Here, part of the North Stand is on the left.

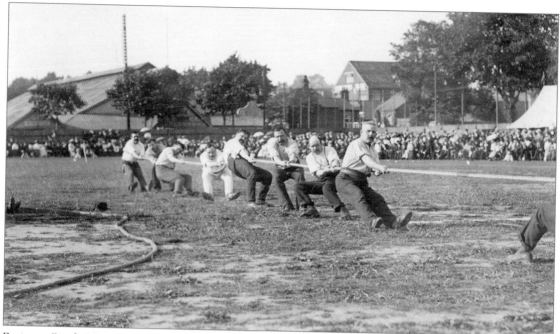

Portman Road, 1912. A tug-of-war competition at the Ipswich sports day. The men are digging their heels in about where the centre spot is now at Ipswich Town Football Club. At the annual meeting of the Ipswich Association Football Club in September 1888 the club made moves to amalgamate with the rugby club based at Portman Road sports ground. In October 1888 an agreement was reached and the new club was called Ipswich Town Football Club. The ground was used for many sports and large events and still belongs to the Ipswich Council. The Empress Skating rink featured on p. 86 is in the left background.

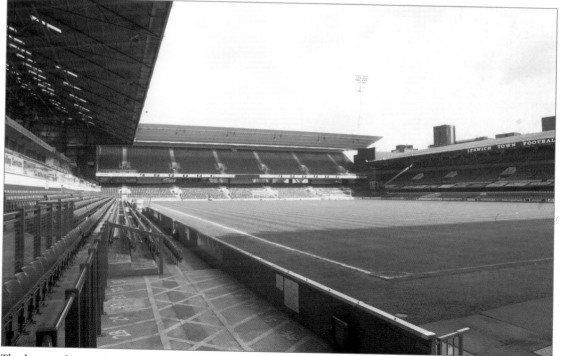

The home of Ipswich Town Football Club from close to the same viewpoint as the picture above.

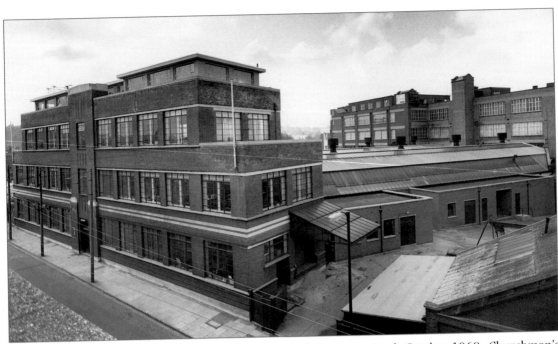

Churchman's cigarette factory where thousands worked, Portman Road, October 1960. Churchman's was founded in 1790 as a wholesale tobacconist at Hyde Park Corner where Westgate Street and Crown Street meet. In 1898 the company moved to the corner of Portman Road and Prince's Street. In 1902 it became part of the Imperial Tobacco Company. The company expanded on to nearby sites and eventually traded as John Player. The buildings in the background have been demolished.

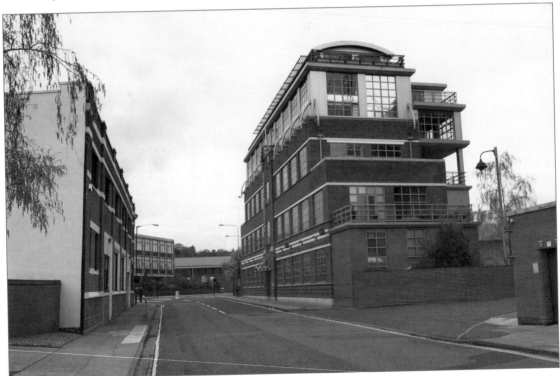

The former cigarette factory in Portman Road has been converted to apartments, April 2004.

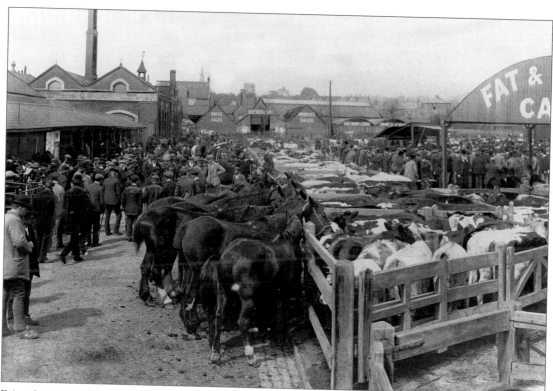

Prince's Street, c. 1910. The Cattle Market moved to marshland between the then new Portman Road and Prince's Street in 1856. The former site at the top of Silent Street is still known as the Old Cattle Market. This view of the Prince's Street site shows a busy day's trading under way. Tuesday was market day in town when hundreds of farmers would bring their stock in to sell.

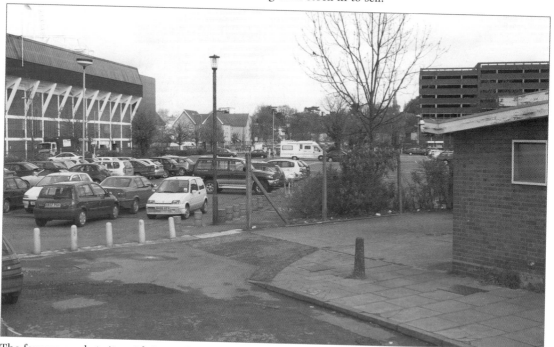

The former market site with Ipswich Town Football Club in the background on the left, April 2004.

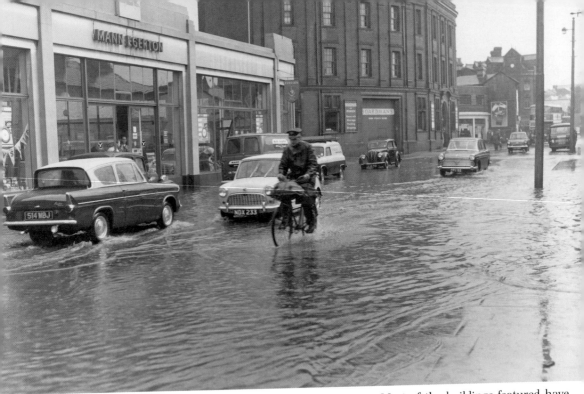

Prince's Street, July 1963. The road was flooded by summer rain. Most of the buildings featured have since been demolished. On the left is Mann Egerton's agricultural vehicle division. Beyond Mann Egerton is the junction of Tanners Lane and Friarsbridge Road with Boardmans storage and removal company warehouse.

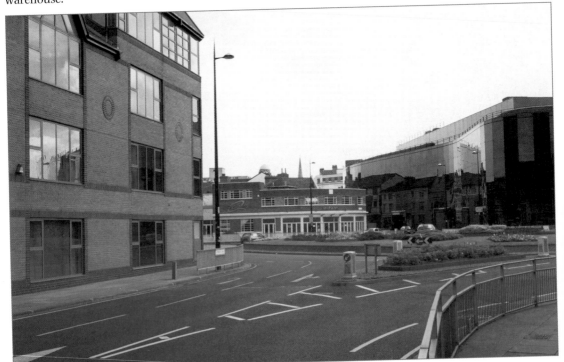

Prince's Street, April 2004. The warehouse in the centre of the 1963 picture is where the Prince's Street and Civic Drive roundabout is now. The glass-clad Willis insurance company office is on the right.

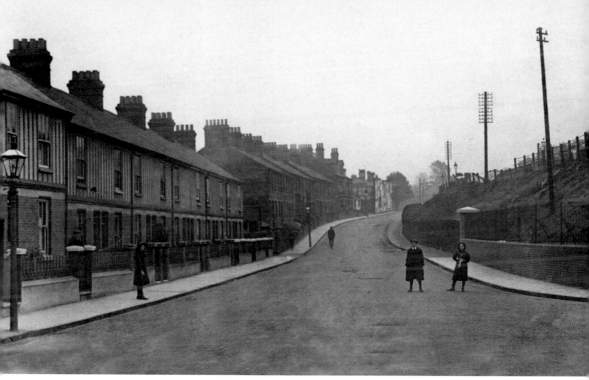

Ranelagh Road, *c.* 1912. This postcard view was taken from the junction of Ancaster Road (right). This image, looking towards the railway station, features a row of houses, which backed on to the River Orwell.

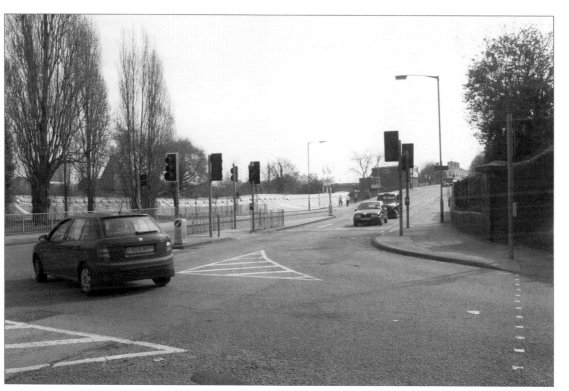

The houses have been demolished in this view, April 2004.

The Orwell Bridge spans the River Orwell from the Strand at Wherstead to the area known as the Lairs, close to Gainsborough housing estate and the former airport site, now the Ravenswood development, April 2004. The bridge was built as part of the southern by-pass connecting Claydon with Martlesham, taking traffic away from the town centre. Work began on the bridge in late 1979. It opened to traffic on Friday 17 December 1982.

Pipers Vale, 1950s. The Pipers Vale swimming pool was a popular attraction for all ages on a warm day. It stood on the east side of the River Orwell close to where the bridge is now. It opened in 1937, and was planned for both sport and leisure use. When it opened there was a shingle beach at the sunbathing area, and the pool's deep end had diving boards. There was a separate paddling pool for young children. Pipers Vale pool closed during the 1970s.

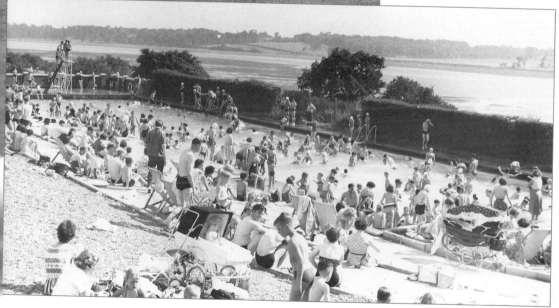

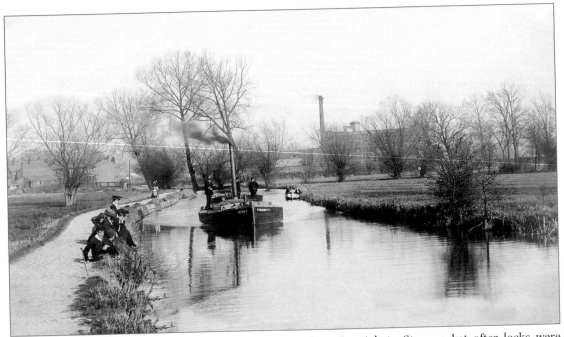

The River Gipping, *c.* 1910. The river was navigable from Ipswich to Stowmarket after locks were constructed. Barges carried cargo to and from Ipswich from 1793. When this picture was taken near Riverside Road, trade with Stowmarket by river had ceased and Bramford was as far as the barges travelled. Most of the barges were carrying imported phosphate to E. Packard & Company to be made into fertiliser. This picture looks towards the town centre with the houses of Riverside Road on the left.

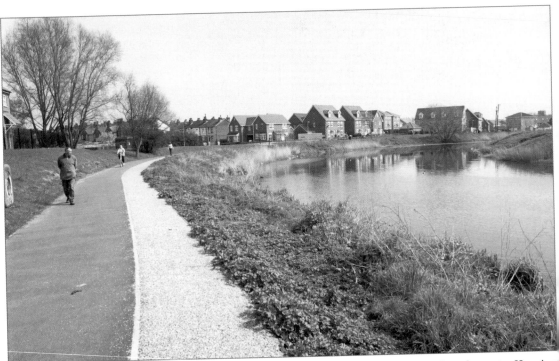

April 2004. The former towpath along the River Gipping is now a pedestrian and cycle route. Housing has been built on the former industrial site where the tannery used to stand.

Fore Street, *c.* 1890. The Earl
Grey public house (right)
stood at the junction of Fore
Hamlet and Back Hamlet.
Duke Street roundabout
would be in the foreground
of this view now. All of the
buildings have gone.

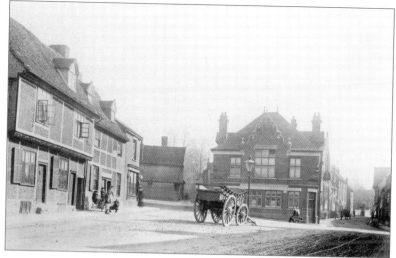

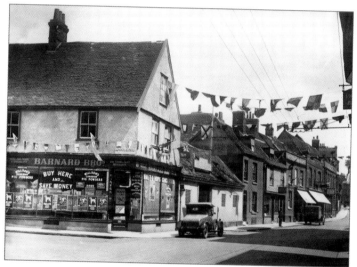

Fore Street, June 1930. This is the
junction with Grimwade Street
(then Church Street). In the
foreground on the corner are
Barnard Brothers, corn merchants,
next to the Sorrel Horse Inn. Other
businesses and premises featured
are Richard and Death, wire works,
William Hurn, tobacconist's, Victor
Cox's boot repairs, and the Ipswich
Social Settlement, a public facility
for religious and social events.
There was also a Penny Savings
Bank in the building. The Empire
Cinema was also operated from
here; it was affectionately known as
the 'Tuppenny Rush'.

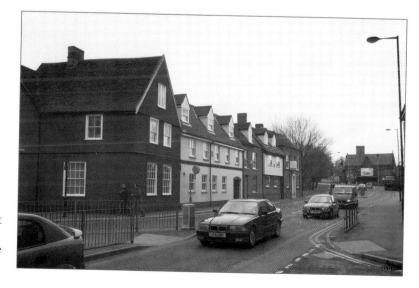

Fore Street, April 2004.
The junction of Fore Hamlet
and Back Hamlet is on the
right of this view. Grimwade
Street is off to the left.

Fore Hamlet, late 1940s, seen from the junction of Myrtle Road. Tiny terraced houses then lined the narrow street where thousands of workers from the nearby works of Ransomes Sims & Jefferies would fill the roadway as they cycled to and from work. Cavendish Street is off to the right of this view and Albion Street to the left.

Fore Hamlet, 1930s. This driver with his horse and cart were taking part in a parade heading for Holywells Park. They are making their way past the now demolished houses at the bottom of Bishop's Hill.

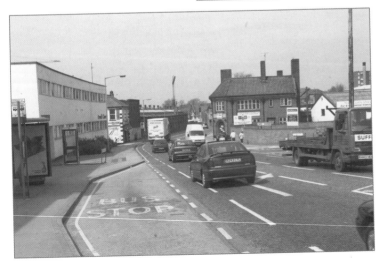

Fore Hamlet, April 2004. This picture was taken from the junction with Fore Hamlet and Bishop's Hill. The building at the corner of where Albion Street was (to the left of the lorry in the top picture) is still there.

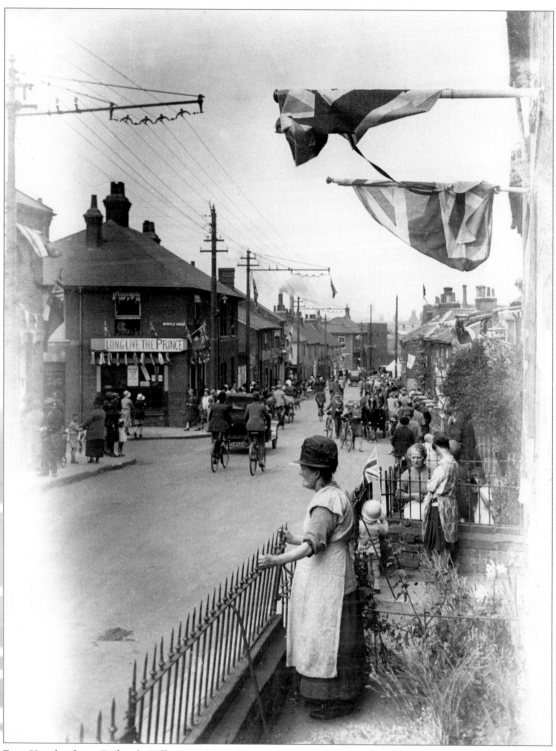

Fore Hamlet from Bishop's Hill, June 1930. The Prince of Wales was visiting Ipswich to officially open the new airport. He also visited Ransomes Sims & Jefferies engineering works in Duke Street. The sign to greet the prince as he passed by is at the corner of Myrtle Road. The buildings on the distant left-hand side of the street at the corner of Albion Street are all that remain of this view.

Christchurch Street, 1940s. Sidney Colthorpe stands outside his off-licence at the corner of Christchurch Street and Cemetery Road. Houses all over town were converted to shops and businesses flourished when shopping was a daily event for housewives. Huge supermarkets and shopping in bulk by car, as well as home delivery via the Internet, have seen many of the businesses close and the buildings return to housing.

April 2004. The building at the corner of Christchurch Street and Cemetery Road is now converted to flats.

4

Over Stoke

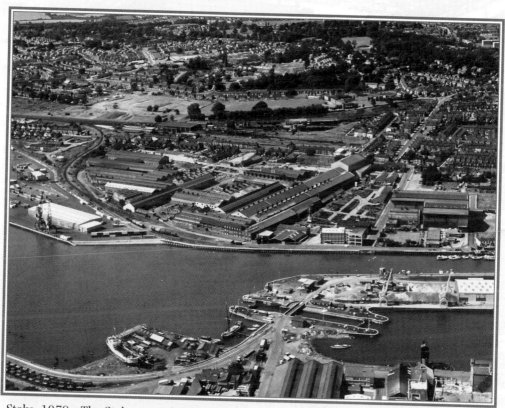

Stoke, 1970s. The Stoke area of Ipswich was a close-knit community separated from the rest of the town by the River Orwell. The huge engineering works of Ransomes & Rapier, where many Stoke residents found employment, dominates this aerial view taken from above Duke Street. By the 1980s, Robert Maxwell's Hollis Group owned the world-renowned 'R & R', as they were known. They closed the company in 1988 amid much sadness in the town. The site has been redeveloped as a mixture of industrial and residential use.

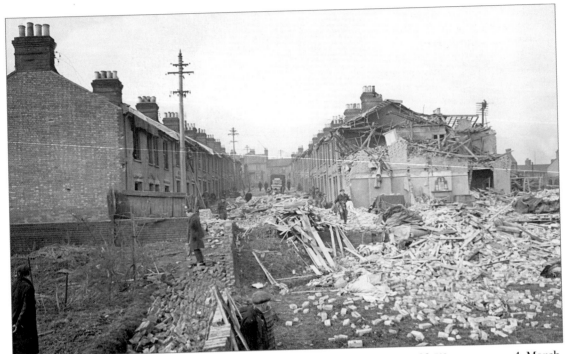

Seymour Road, 1945. The last air raid on Ipswich during the Second World War came on 4 March. Nine people were killed in the raid and six houses destroyed. During the war 225 houses were destroyed and a further 774 severely damaged. Fifty-three people lost their lives in air raids and 164 were seriously injured.

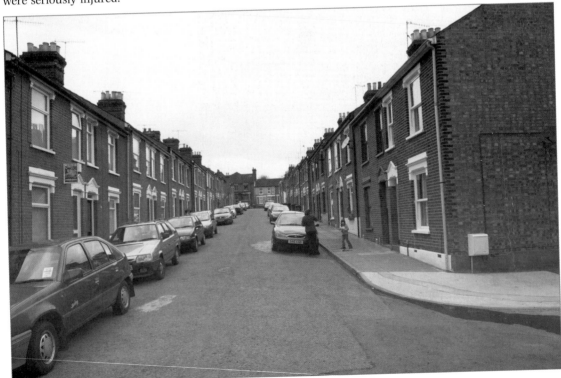

Seymour Road from close to the same viewpoint, April 2004.

Stoke Street, *c.* 1890. These ancient buildings were demolished in 1899 when the People's Hall was built on the site. These old buildings would not have had any mains sewage or running water in this poor part of town.

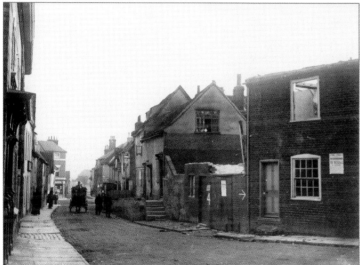

The opposite end of Stoke Street in 1899 as the buildings were being demolished.

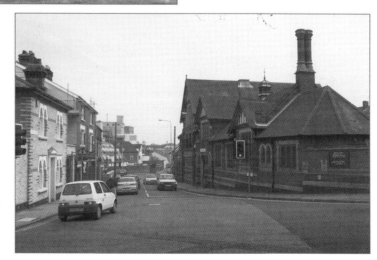

Stoke Street, April 2004. It is now the busy route from the town centre to Stoke Park and Belstead developments.

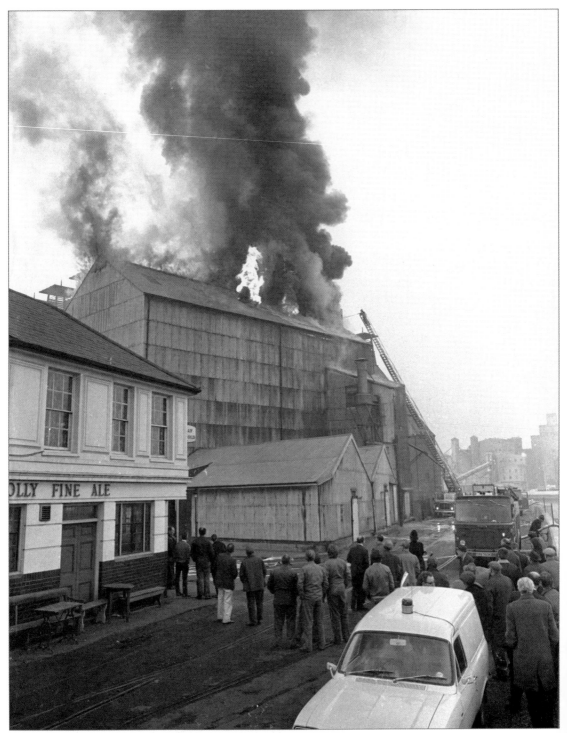

New Cut West, February 1973. Sightseers gathered to watch the fire brigade deal with a blaze at Pauls & Sanders warehouse and maltings at New Cut West. There was a major problem of trying to empty the warehouse, which was effectively a huge grain silo, with one of its 90ft high corrugated iron walls in danger of collapse. Thousands of tons of malt and barley had been saturated with water from the firefighters' hoses, increasing the weight dramatically.

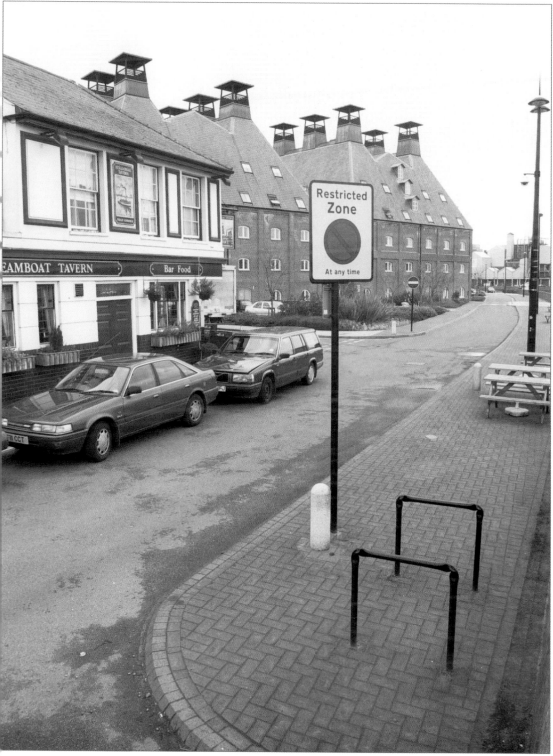

New Cut West, April 2004. After standing empty for many years the huge Victorian maltings building in Felaw Street was converted to office use. The railway lines have gone and the area is block paved. In the foreground is the Steamboat Tavern.

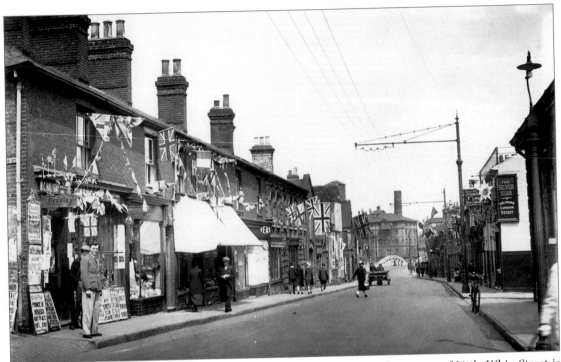

Vernon Street looking towards Stoke Bridge, June 1930. On the left at the corner of Little Whip Street is B. Halliday's newsagent's. On the right is the Silver Star public house, on the corner of Gower Street. In the distance beyond the bridge is George Mason's Mill, a branch of the British Oil and Cake Mills Ltd.

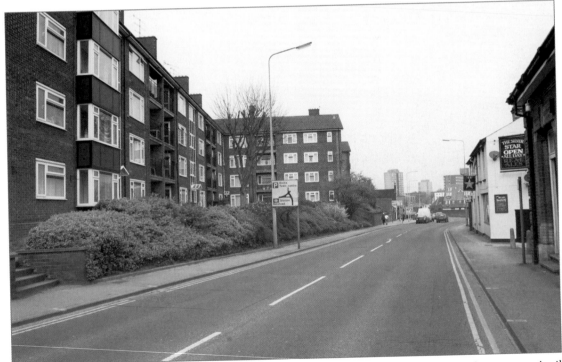

All the shops in this view of Vernon Street, which served the Stoke area community, have gone, April 2004. A block of flats set further back, allowing a wider road, has replaced them.

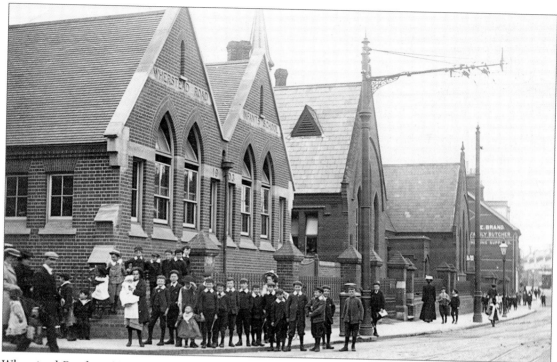

Wherstead Road, *c.* 1910. The Wherstead Road School was built in 1872 and was one of the Ipswich Board Schools. The Education Act of 1870 paved the way for our modern system of education. By 1879 the Ipswich School Board was in charge of eight schools: Argyle Street, California, Cavendish Street, London Road, St Mary Elms, Trinity Street, Whitton and Wherstead Road. In 1903 the Ipswich Local Education Authority succeeded the board. The school was extended to take over a thousand pupils at about the time of this photograph.

Houses now stand on the site between Station Street and Kenyon Street.

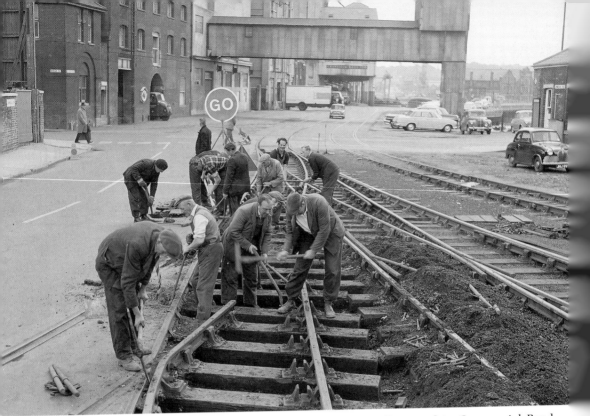

Commercial Road, May 1967. The number of lines from the marshalling yard in Commercial Road, taking rail traffic to and from the dock, was being reduced at this time. Rail crossings over Bridge Street used to bring traffic to a stop as lines of trucks loaded with cargo crossed over. Stoke Bridge is off to the right of this view.

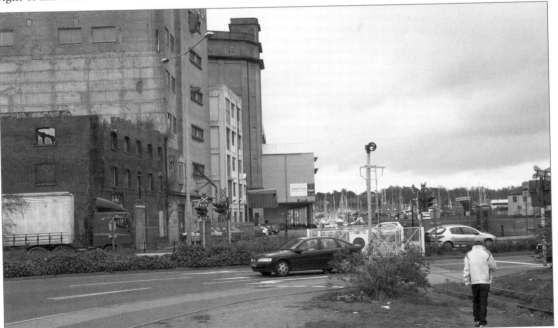

Commercial Road, April 2004. The area is now part of the busy double roundabout system near the Novotel and St Peter's Church. Commercial Road is now named Grafton Way. The building on the left was destroyed by fire in April 2000.

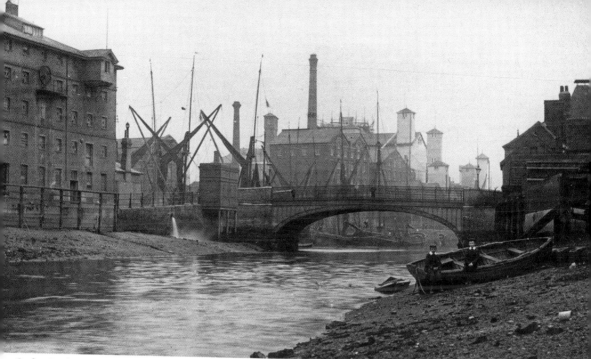

Stoke Bridge, *c.* 1900. This iron bridge was built in 1819 to replace a stone structure swept away by floods. The present concrete one replaced this iron bridge. Work started in September 1924 and the bridge opened in 1925.

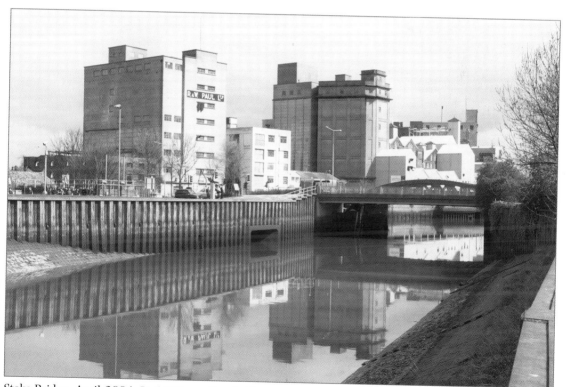

Stoke Bridge, April 2004. In 1983 another bridge was added to create a dual carriageway over the River Orwell at Stoke. Flood barriers now line the river. The large building which was Mason's Mill has been demolished, and is now the site of a skateboard park.

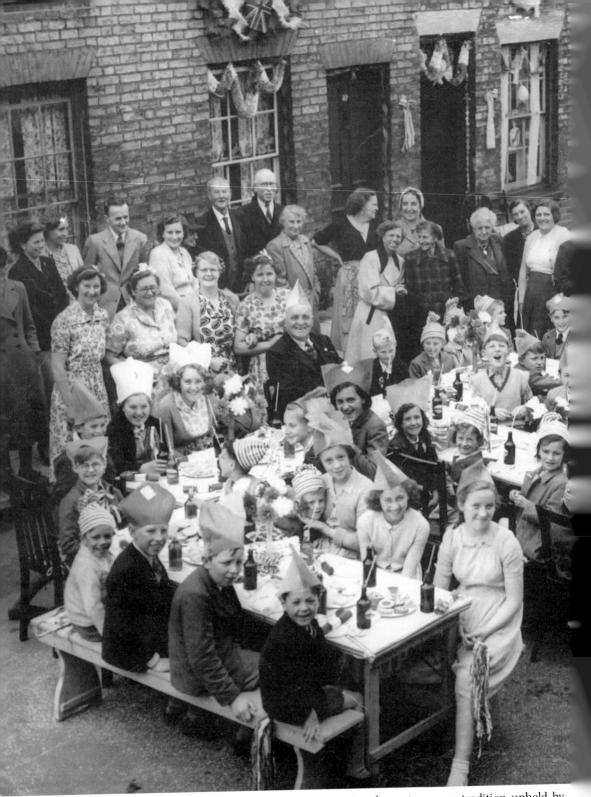

Tyler Street, 2 June 1953. Street parties to celebrate major national events were a tradition upheld by the community who lived 'Over Stoke'. Coronation Day was cold and wet but nothing would stop the families of Tyler Street enjoying their party. Tables and chairs were set out in the street and jelly and ice cream was enjoyed by all.

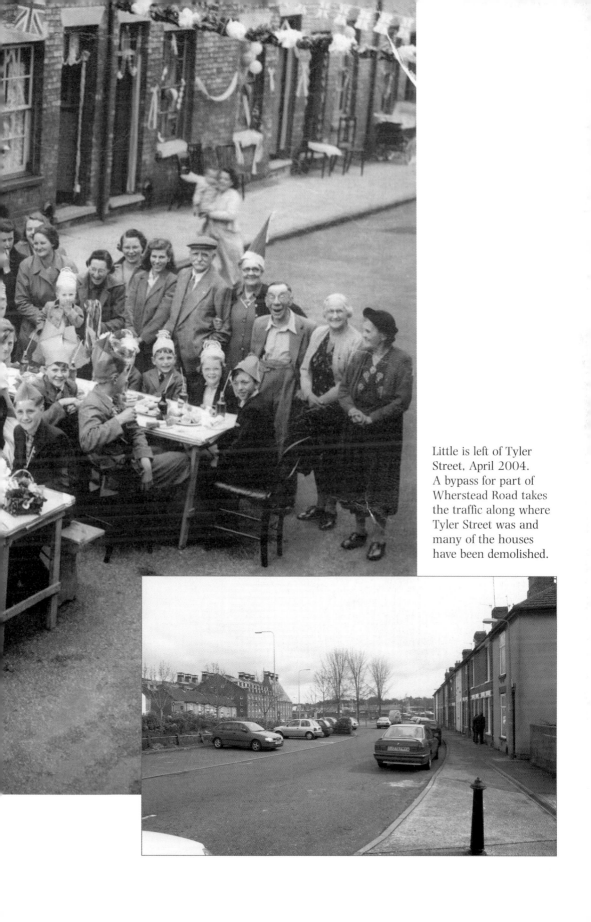

Little is left of Tyler Street, April 2004. A bypass for part of Wherstead Road takes the traffic along where Tyler Street was and many of the houses have been demolished.

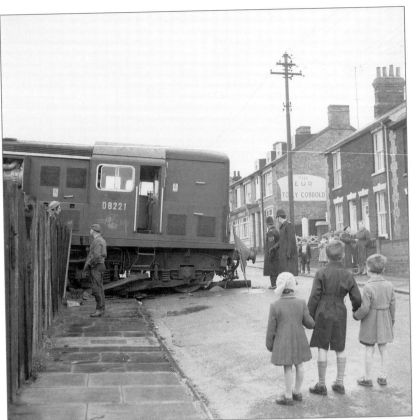

Croft Street, November 1963. A major feature of life 'Over Stoke' was the Ipswich locomotive yard where British Rail rolling stock was maintained. The original Ipswich station was close by until 1860 when the tunnel through Stoke Hill was built and the present station opened. Residents of Croft Street were used to the workings of the maintenance yard at 'Ipswich Loco', but nothing could have prepared them for the day when a diesel locomotive crashed through the buffers and fence into the road. Fortunately there were no injuries.

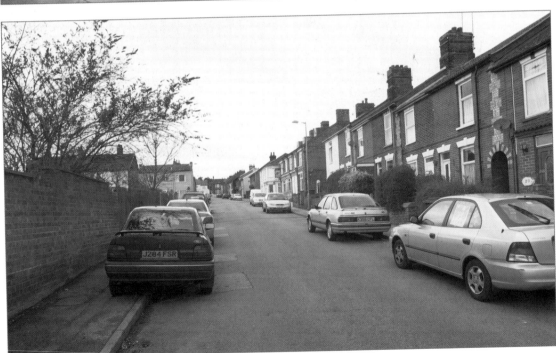

All quiet in Croft Street, April 2004. The EUR public house (named after the Eastern Union Railway) is visible on both pictures.

5

Transport

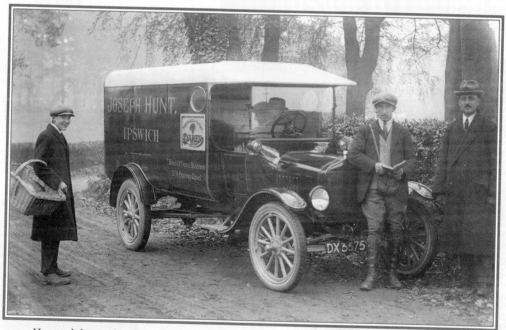

Home delivery by the milkman and baker was a daily event when Joseph Hunt's van was photographed in about 1930. Hunt's had a bakery and dairy at 331–33 Spring Road.

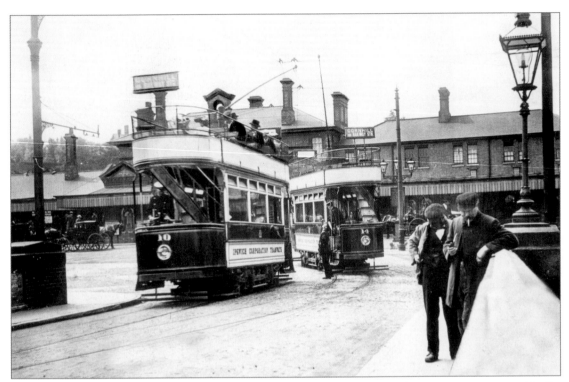

The railway station from Prince's Street, *c.* 1908. A pair of Corporation electric trams pass outside the station. A conductor looks skyward at the trams' overhead power arm as two men on the bridge over the River Orwell check their watches.

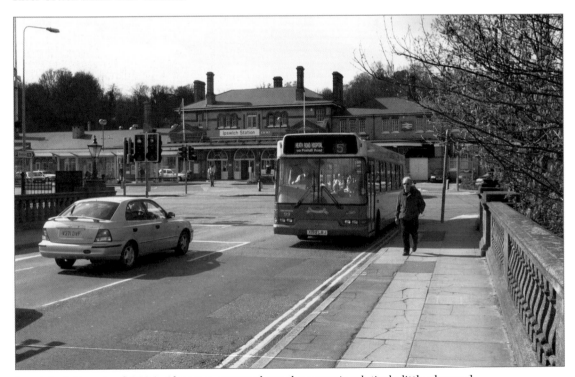

Ipswich station, April 2004. Almost a century later the scene is relatively little changed.

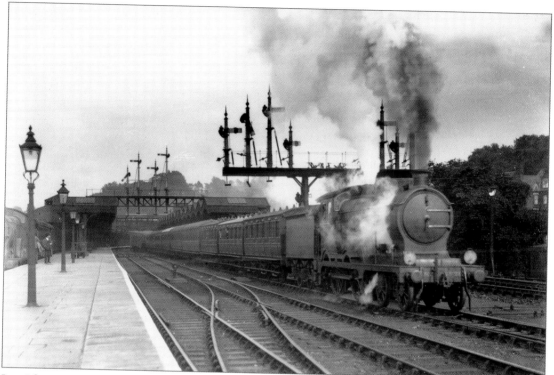

Ipswich station, 1930s. A steam train pulls away from the platform. The main station building is on the far left. The platform was lit after dark by the elegant gas lamps featured on the left.

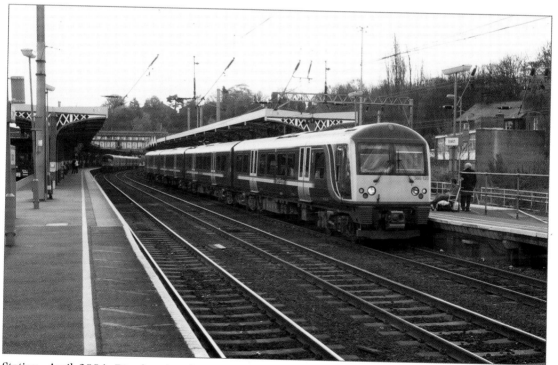

Station, April 2004. Diesel replaced steam in the 1960s. In both of these views taken about seventy years apart the houses of Gippeswyk Road are on the extreme right.

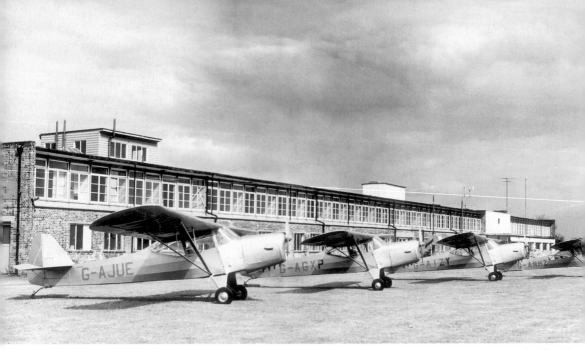

Ipswich airport, 1972. The airport was opened on 26 June 1930. Aircraft from all over England and a few from Germany were lined up on the new airfield when the Duke of Windsor performed the opening ceremony. Local builders Sadler and Company built the terminal. It is one of only two surviving examples of what was then seen as a revolutionary new design. It is now a listed building. The airfield was used by the RAF during the Second World War. Later there were passenger services out of Ipswich with companies including Channel Airways and Suckling Aviation. Parachute training was a feature of leisure flying. In 1996 the Ipswich Council announced, amid much controversy, the closure of the site for redevelopment. The last aircraft to leave, after rebuilding, was in January 1998. Four Auster aircraft of the East Anglian Flying School are seen outside the terminal building.

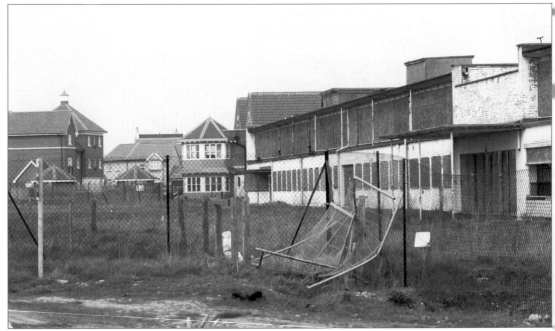

Ipswich airport, April 2004. New buildings including Jamie Cann House, a home for the elderly, surround the former airport terminal building, which is to be restored.

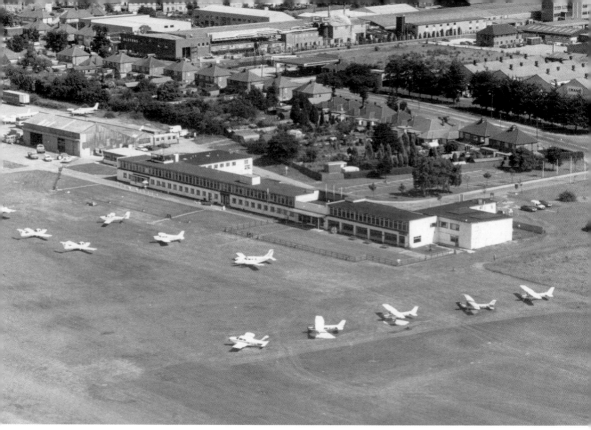

An aerial view of Ipswich airport from the 1980s, featuring the terminal building. The runways and standing area were all grass.

Ravenswood, April 2004. Housing being built on the former airport site. A new school and a home for the elderly are also part of the Ravenswood development on the former airport site.

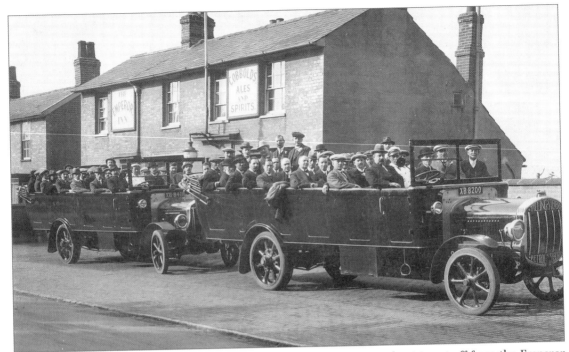

Norwich Road, *c.* 1925. A pair of charabancs loaded with passengers about to set off from the Emperor Inn. These large open-topped vehicles had a speed limit of 12mph. In this period, when few had their own transport, it was the chance of a day out to visit an out-of-town public house for a game of darts or quoits.

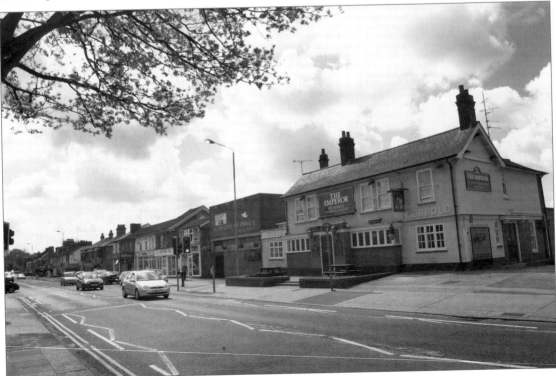

The Emperor has seen many alterations since the 1920s photograph was taken.

6

Events

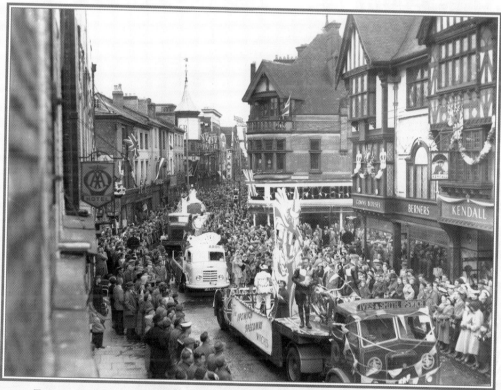

Tavern Street, 2 June 1953. As photographers captured events they also recorded
the street scenes at a moment in local history. This picture was taken from a window at the
White Horse Hotel in Tavern Street as the Coronation Day parade passed by. The float in
the foreground was an entry by Ipswich Speedway. In the background is Carr Street,
including the turret of the East Anglian Daily Times Company building at the corner of
Little Colman Street. All the building beyond Little Colman Street was replaced
with a shopping precinct in the late 1960s.

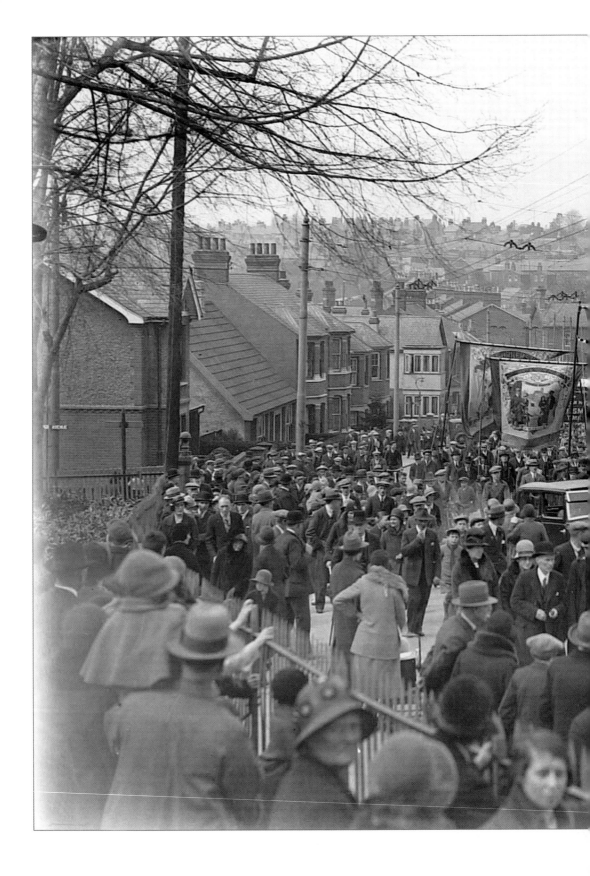

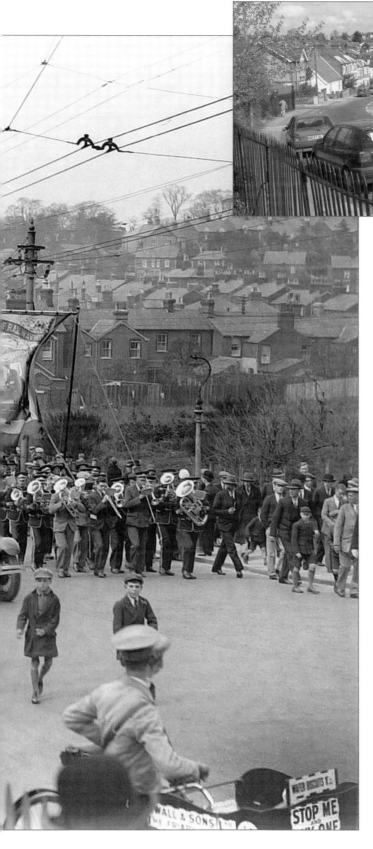

Houses have replaced the open space on the right of this view, April 2004.

Grove Lane, 1930s. A brass band leads a parade along Grove Lane. The trade union banners would suggest this was a trade union event. At the front is the National Union of Railway Workers' banners. Spectators in the foreground watch from Alexander Park.

Crown Street, 2 June 1953. Heavy showers did not stop the crowds filling the pavements as the Coronation Day parade passed along Crown Street. In the background is Egerton's garage. This large garage building occupied the whole site between Peel Street and William Street. It was demolished in the early 1970s.

Crown Street, April 2004. The Crown Pools complex now stands where Egerton's garage was. Mayor Anne Smith laid the foundation stone in April 1982. Mayor Peter Gardiner officially opened the complex in May 1984.

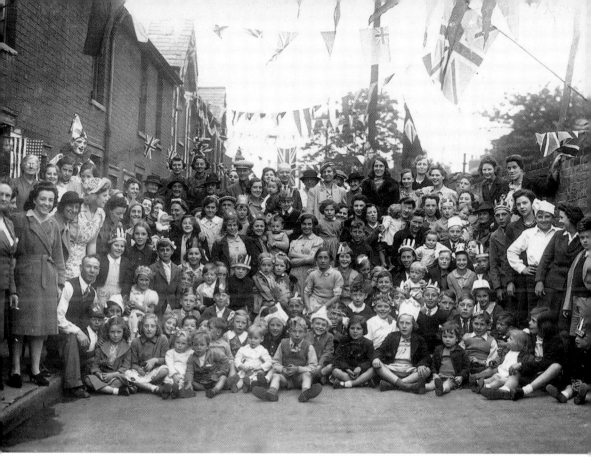

South Street, May 1945. Residents of South Street were part of the community around the Norwich Road area of town. Events like this Victory in Europe day celebration were well attended.

Little housing remains in South Street. Most of the houses have gone and the space used as a car park.

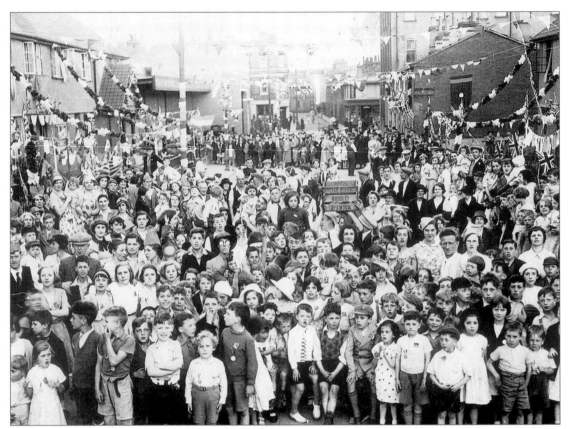

Curriers Lane, May 1937. The area around The Mount and Prince's Street was packed with hundreds of small terraced houses. Residents of the area held a street party to celebrate the Coronation of King George VI. In the background is Edgar Street with the British Lion public house on the left corner.

Curriers Lane, April 2004. St Francis Tower, part of the 1960s Greyfriars site, is where Edgar Street used to stand.

Black Horse Lane, May 1945.
This street close to the town
centre was packed with residents
when this Victory in Europe party
photograph was taken.

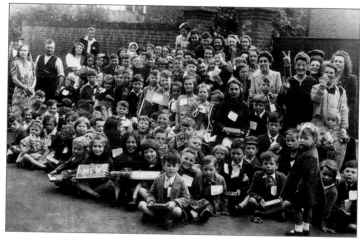

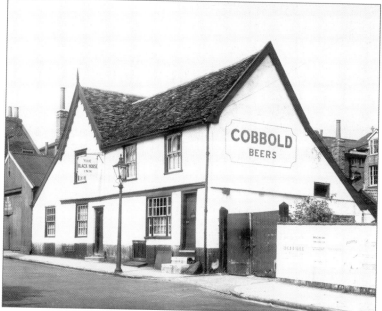

The Black Horse public house
as it was in the late 1940s.

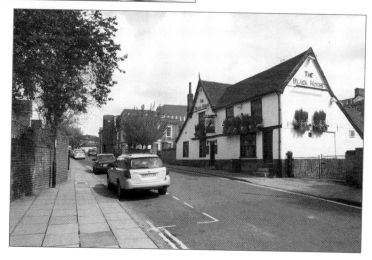

Black Horse Lane and the public
house in April 2004.

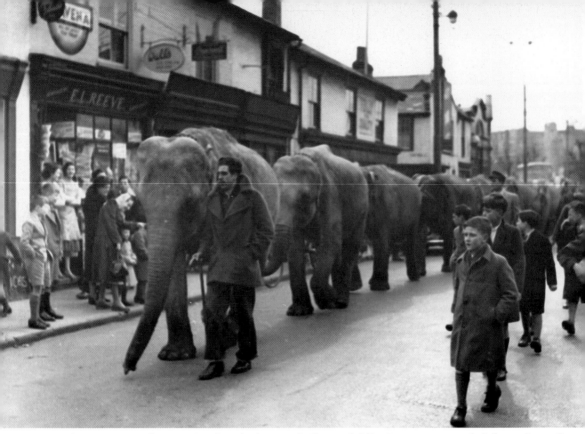

Prince's Street, October 1961. The elephants of Chipperfield's Circus are paraded from the railway station to Christchurch Park. Visiting circuses used to travel to towns by train. The buildings on the left were between James Street (off the picture to the left) and Portman Street.

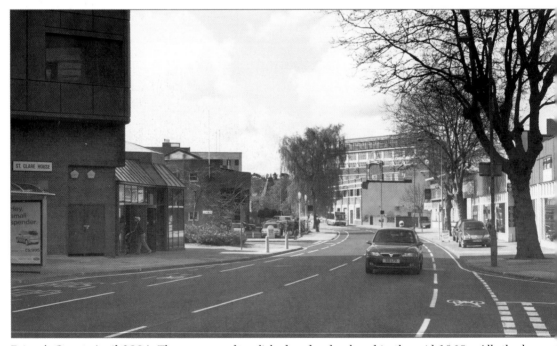

Prince's Street, April 2004. The area was demolished and redeveloped in the mid-1960s. All the houses and businesses from the image above have gone. The Greyfriars complex now stands on the site.

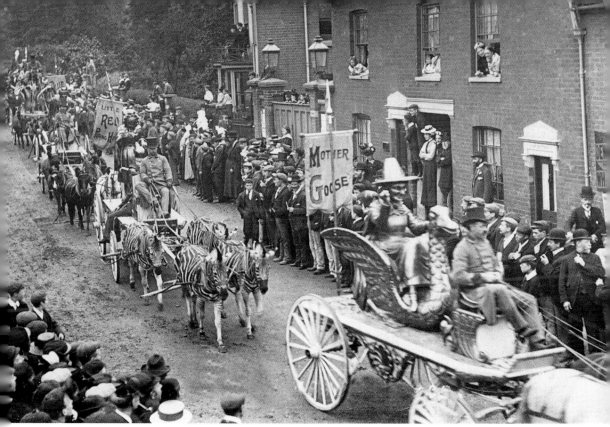

Fonnereau Road, 1899. Barnum and Bailey's world-famous circus visited Ipswich in 1898 and 1899. Huge crowds lined the streets to watch the spectacle. Many of the animals would have amazed spectators, who would have had little or no chance to see the sights the circus brought to town. The parade through town from Christchurch Park was photographed at the corner of Crown Street and Northgate Street, from the Halberd public house, as the parade turned into St Margaret's Plain from Fonnereau Road.

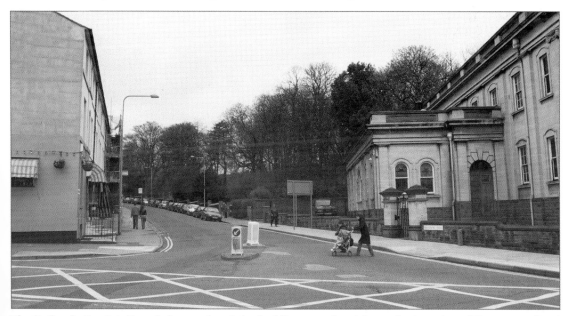

The Bethesda Baptist Church has replaced the buildings on the right at the junction of Fonnereau Road and St Margaret's Plain, seen here in April 2004.

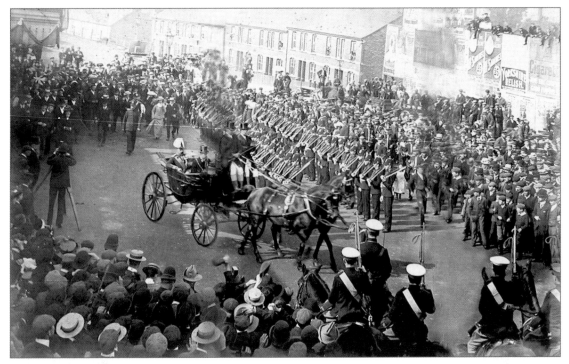

Ipswich station, 1902. Lord Kitchener was made a Freeman of Ipswich in September 1902. This picture was taken from the canopy of the station as he set off by carriage for the Town Hall. A guard of honour saluted the honoured guest as crowds lined the route. Lord Kitchener, the face of the First World War recruiting poster, 'Your Country Needs You', is in the carriage with Mayor Arthur Churchman. The row of terraced houses in the background in Ranelagh Road is featured on p. 91.

The view from the station forecourt, April 2004.

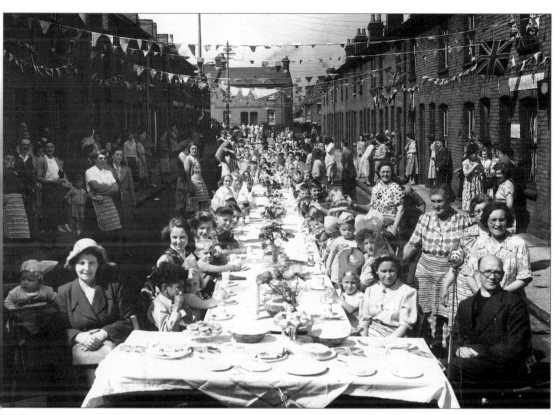

Pauline Street, 2 June 1953. Residents celebrate the Coronation of Queen Elizabeth ll.

Pauline Street, April 2004. The Victorian terraced houses of Pauline Street were built when most people walked to work or school. Many of the residents of the street would have worked at nearby engineering works or the British Rail Locomotive maintenance yard. Now parked cars fill much of the space where Coronation Day celebrations took place over fifty years earlier.

ACKNOWLEDGEMENTS

This book would not have been possible without the many kind people who have brought photographs of Ipswich to add to my archive of vintage images. My special thanks are due to Colin Barber for access to many fine postcard images of Ipswich. Postcard collector Dennis Ellis has also made important contributions.

Also to Stephen Cordery who brought me an excellent set of glass negatives of events in the town from the 1930s to the 1950s.

To Doug Cotton who rescued the work of Ipswich photographers the Titshall Brothers from the 1920s and '30s. I am forever indebted for his hours of work in the 1950s to separate abandoned wet glass negatives from the photographer's garden shed in Spring Road, which he added to my files in the 1980s.

Thanks also to the Ipswich Council Museums and Galleries for access to the images of Whitton.

The photographs of the Bond Street fire station are by kind permission of the Suffolk Fire and Rescue Service.

I am grateful to those who gave me access to vantage points high above the town from which photographers had worked many years before.

My sincere thanks to everybody who has contributed to this project.

David Kindred, 2004

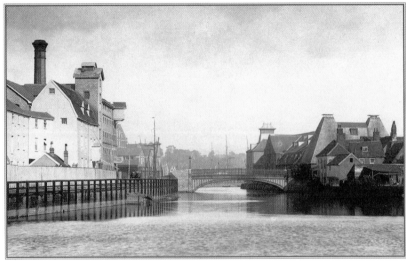

Stoke Bridge from the River Orwell, *c.* 1890. The iron bridge seen here opened in September 1819, and was built to replace the stone bridge which was washed away in a flood in April 1818, when six punts were lashed together with decking as a temporary measure. It was the only crossing of the river within the town. The present bridge opened in 1925. The Prince's Street Bridge was not built until 1949. The site of the mill on the left is where the skateboard park is now. The building on the right, just beyond the bridge, was used as a barracks during the wars with France; it is now converted to flats.